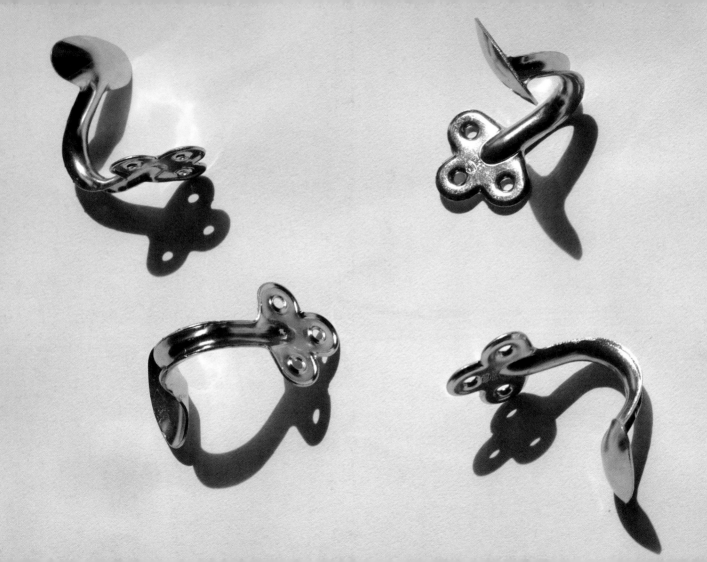

Alison Milner

Inspirational Objects

A visual dictionary of simple, elegant forms

A & C Black • London

The Herbert Press
A & C Black Publishers Limited
Alderman House, 37 Soho Square
London W1D 3QZ
www.acblack.com

ISBN-10: 0-7136-6819-9
ISBN-13: 978-07136-68193
Copyright (c) Alison Milner 2005

Catalogue records for this book are available from the British Library and the US Library of Congress.

Photography by Steve Speller and Alison Milner
Design concept by Alison Milner
Design layout and typography by Andy Thomas
Cover design by Peter Bailey
Copyedited and proofread by Julian Beecroft

Printed in China

A & C Black uses paper produced with elemental chlorine-free pulp, harvested from managed sustainable forests.

Dedication

To my Mum, who made me logical,
my Dad, who made me symmetrical,
and to Steve, Wilf and Felix, who
keep me happy.

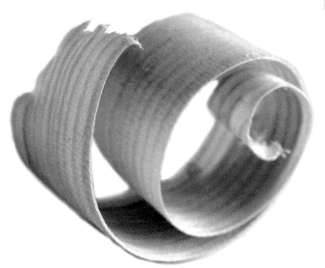

Introduction

This collection of pictures was started in the 1980s. I originally called it '100 Objects to Leave Home with'. At that time it consisted of a series of photographs of objects from my home and studio, which were my personal obsessions and design inspiration. I wanted a record of them so that I could take them with me when working away from home. The photographs continued to be added to over the years.

All the objects are small, anonymous and beautifully formed, with an abstract appeal. I am interested in objects which demonstrate the relationship between material, process and form, and where the result is something with elegance, personality and usability. The objects are a very eclectic mix: including modern and retro manufactured items, packaging, handmade craft items, natural objects and a few of my own design maquettes and 3D sketches. The choices are visual rather than intellectual, breaking down barriers between the natural and the man-made.

In Nicholson Baker's novel *The Mezzanine*, the

narrator remembers how as a child he made the discovery that, 'anything, however rough, rusted, dirty or otherwise discredited it was, looked good if you set it down on a stretch of white cloth or any kind of clean background'. I have employed the same principle in this book; all the objects are represented as black and white cut-outs and are the same size, irrespective of their real size, so as to aid comparisons which would not normally be made. Careful placing of the objects in relationship to each other and the white space around them also adds to this distancing from

their normal function and context. The objects are arranged into a narrative which only really exists in my mind; objects make connections with other objects, sometimes through their geometry, sometimes by their manufacture and sometimes by their human associations.

The text for the book has been deliberately distanced from the images, and takes the form of notes which use the objects as their starting point but sometimes drift off tangentially. They are inspirational in a similar

way to the pictures; a meandering conversation leading to associations in the mind. The book aims to consider each object from every angle at once. Why do I like it? How do I categorise it? What is it made from? How is it made? What is it for? Could it be different? Has it evolved? What can it mean?

We live in a world dominated by objects. The American product designer Karim Rashid recently estimated that we each interact with 520 different objects every day, the majority of which we take for granted and barely even notice. Advanced technology means it is becoming possible to make almost anything. However, simplicity in design and manufacture still has a resonance for a lot of people who value objects which they can understand in a real, almost physical way. The Japanese have a word, *wabi*, which means tranquil simplicity. An aesthetic and moral principle, *wabi* advocates a life of voluntary poverty and an appreciation of the beauty of the commonplace and the unselfconscious. A lot of the objects I have chosen are from the past or from pre-industrial or early industrial

countries. As a design tutor I am constantly exhorting my students to refine detail or think about finishes. It is interesting that in economically poor countries you often find simple and beautiful objects that have reached this refined state by a gradual and collective process akin to evolution in the natural world.

This book is a visual dictionary of beautiful forms produced by nature or by simple means. It is a plea not to go back to the past but to go forward into the future with a diversification of materials and with a thought for environmental issues. Accidentally breaking something is often seen as a good excuse for a spending spree rather than a time to get out the glue. We should be investing in objects made with sustainability and longevity in mind. After all, our memory is prompted by the objects around us, and if everything is constantly replaced where can our memories linger?

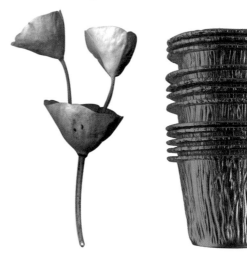

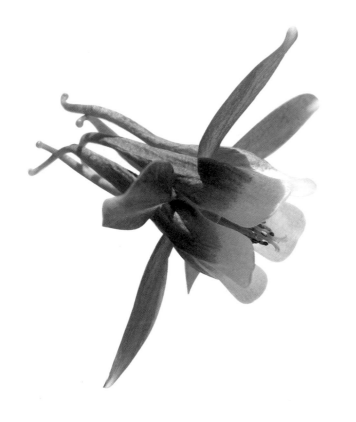

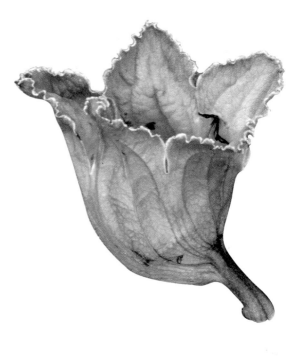

01

02

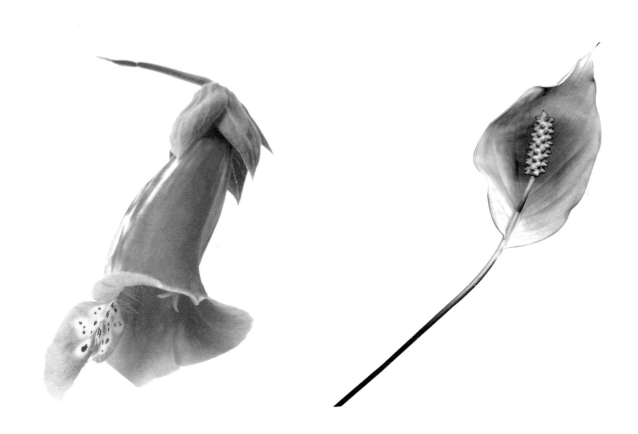

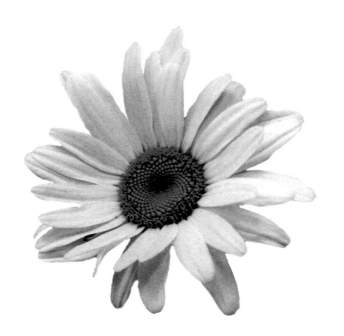

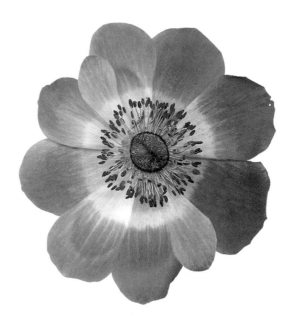

05 06

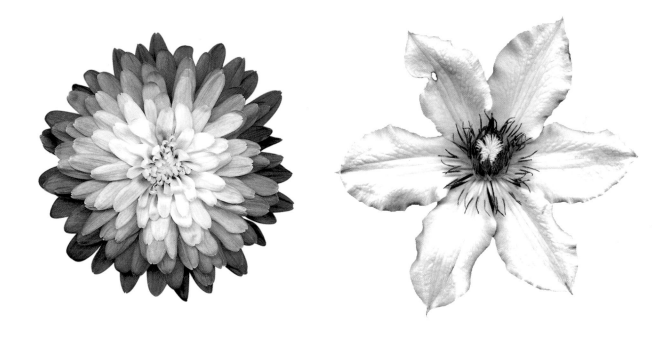

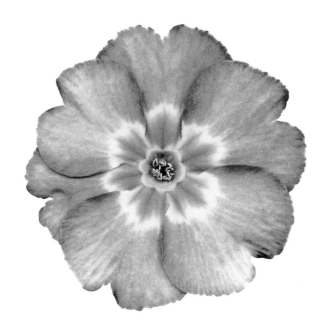

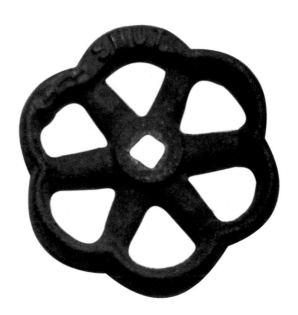

09 10

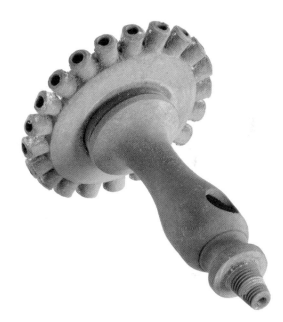

11

12

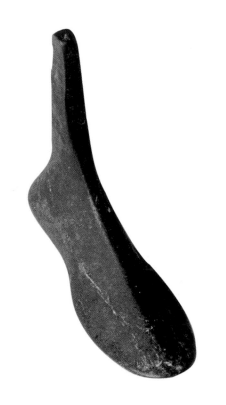

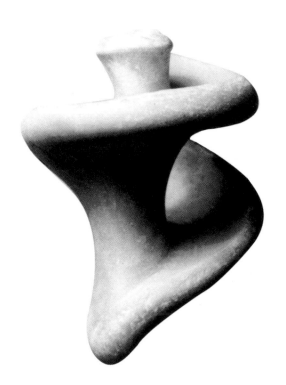

13 14

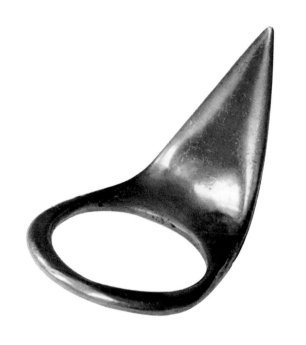

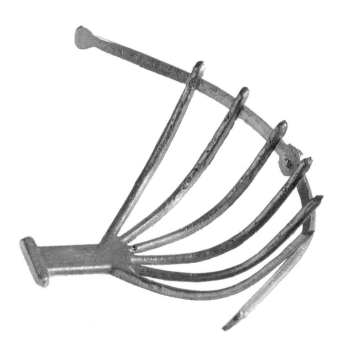

15

16

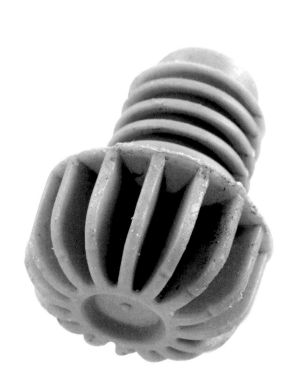

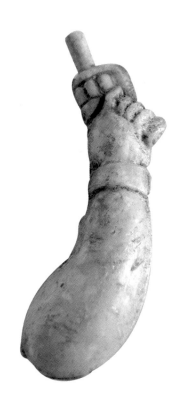

17 18

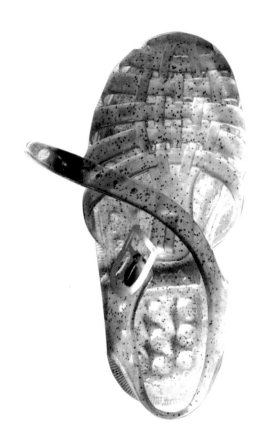

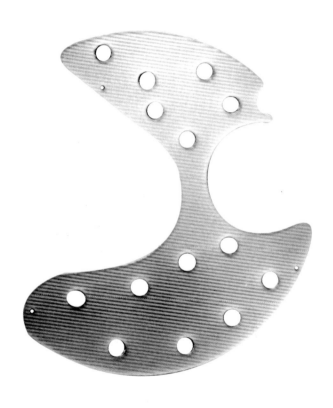

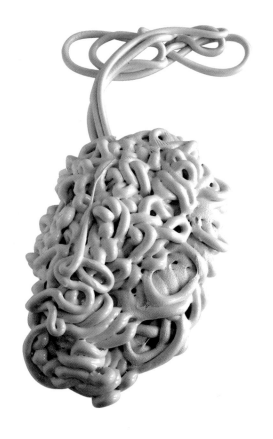

21

22

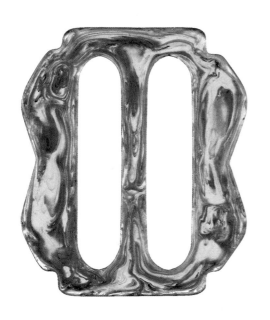

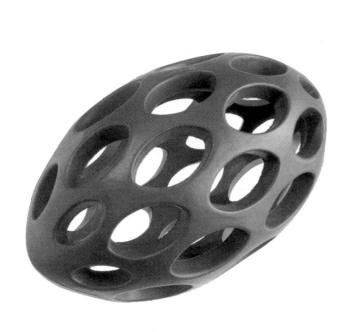

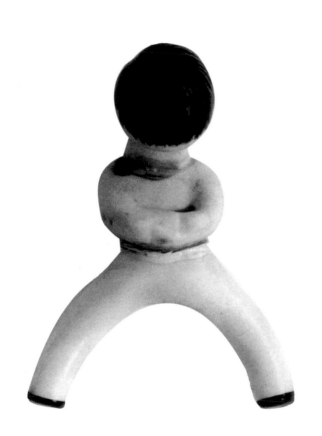

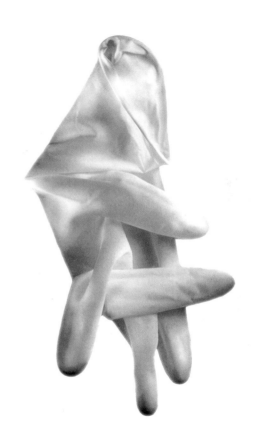

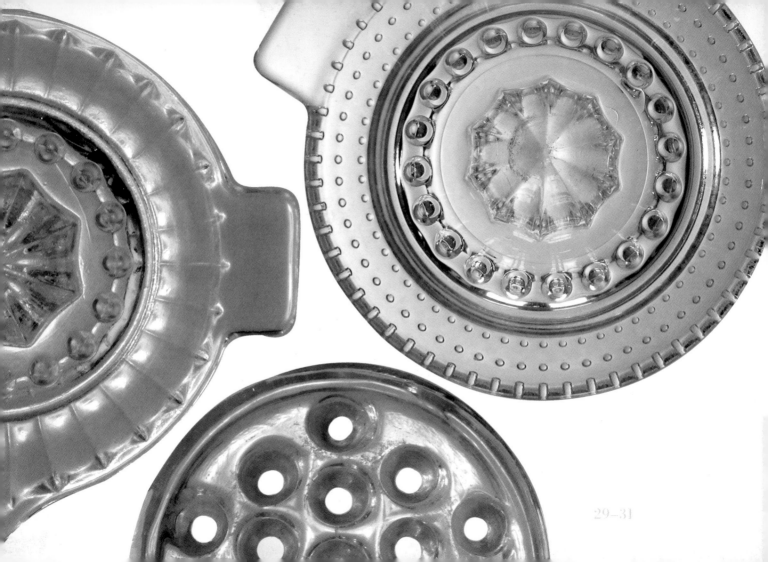

29–31

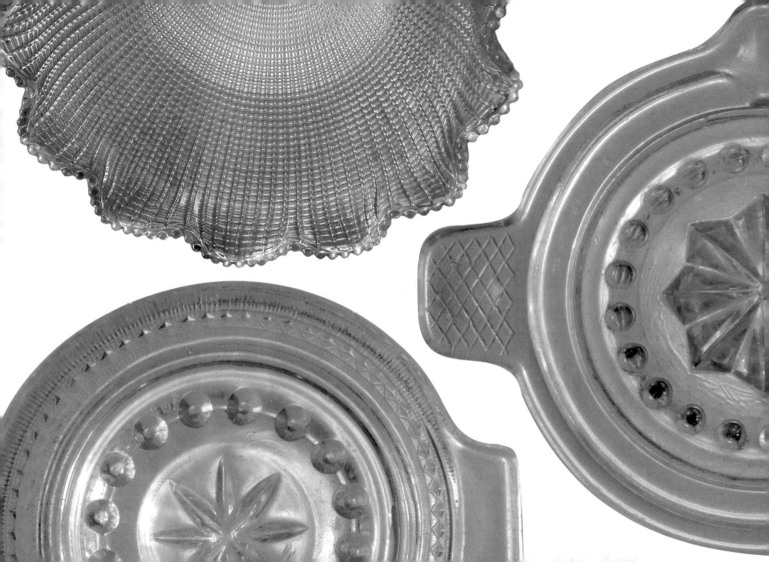

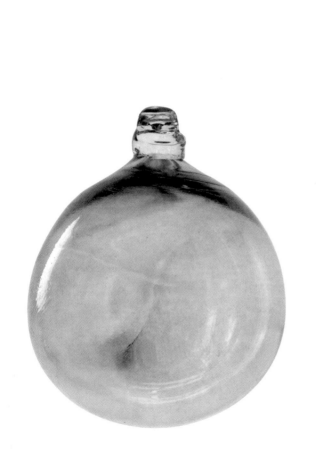

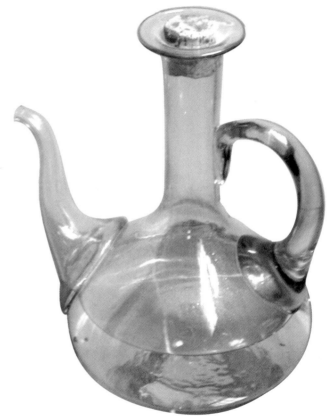

32 33

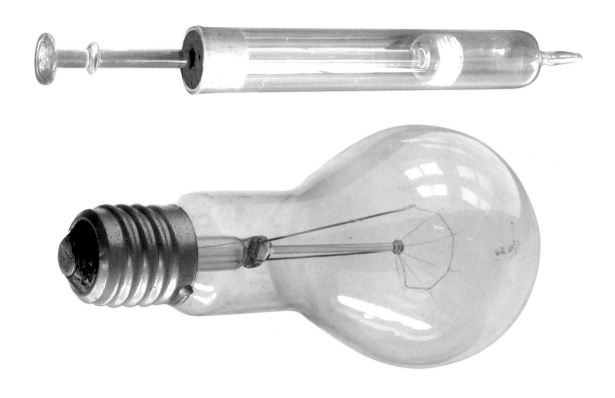

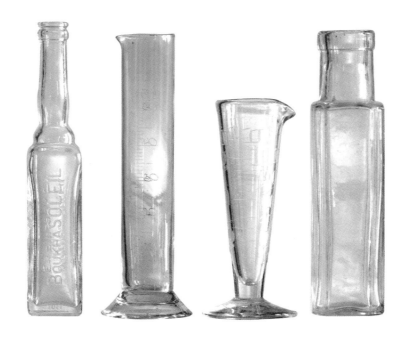

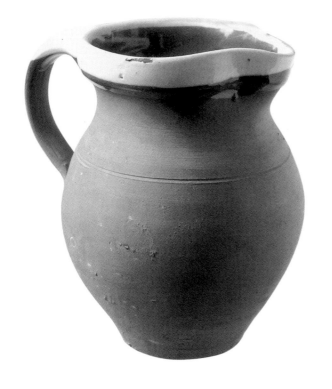

38

39

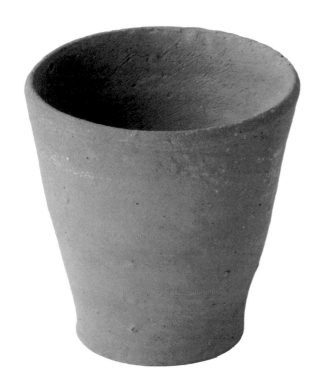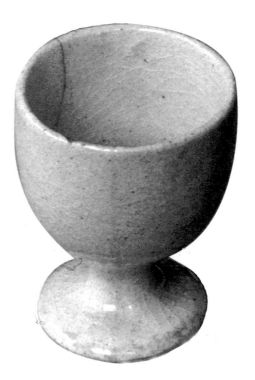

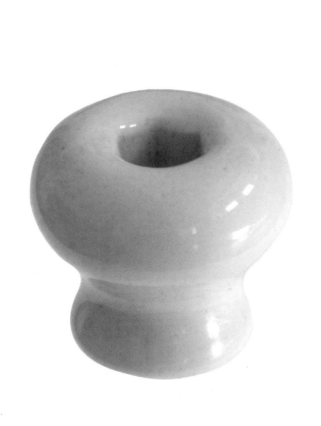

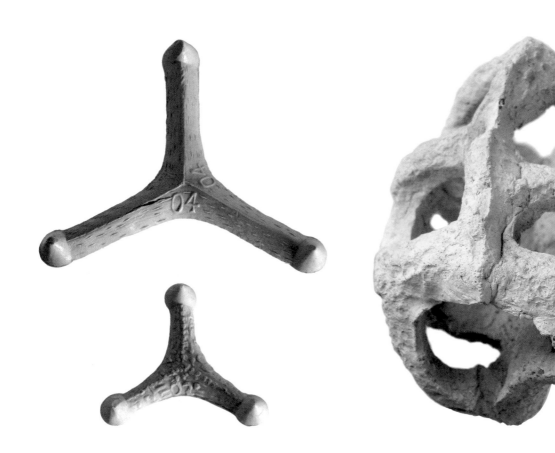

44 45

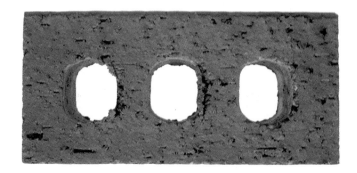

46

47

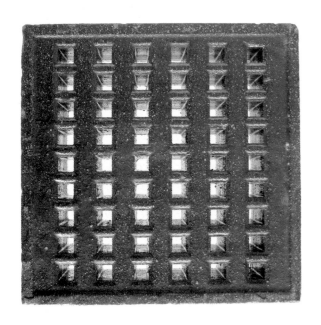

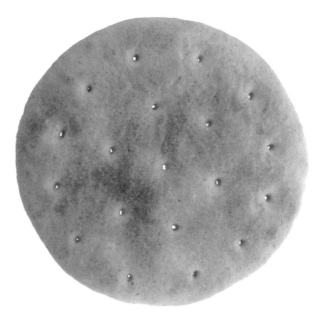

48 49

50 51

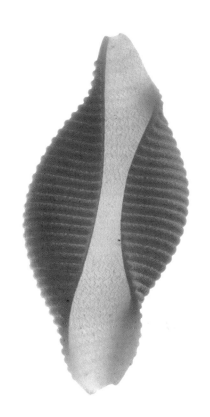

52 53

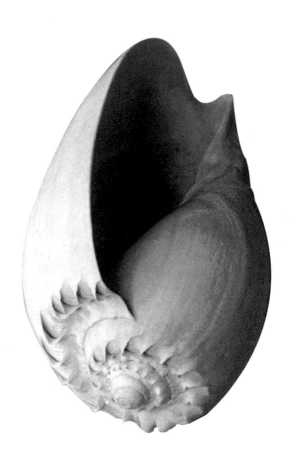

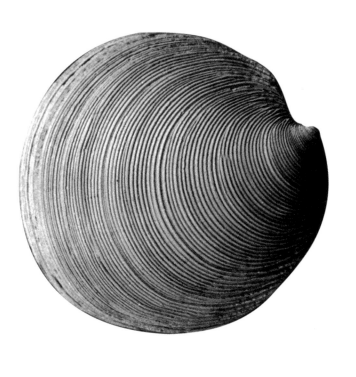

54 55

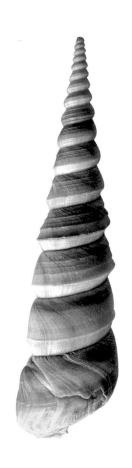

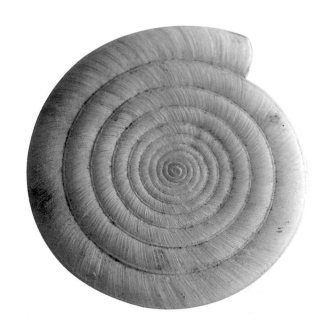

56

57

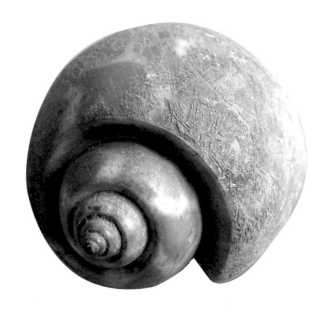

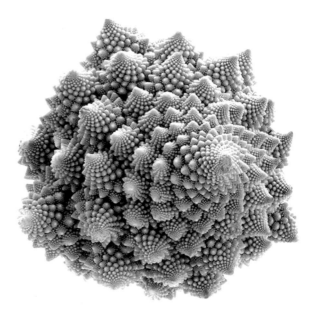

58

59

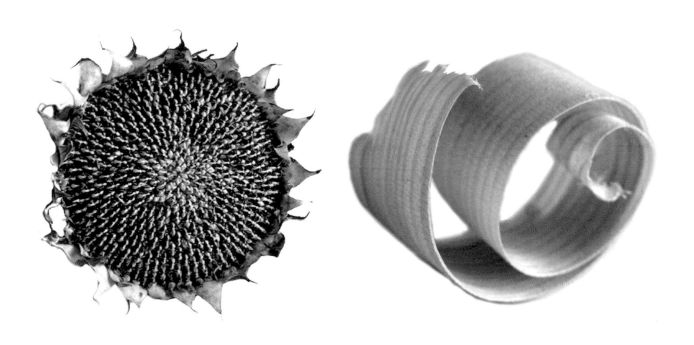

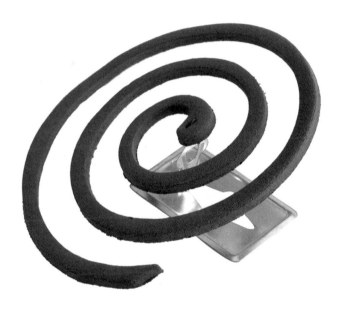

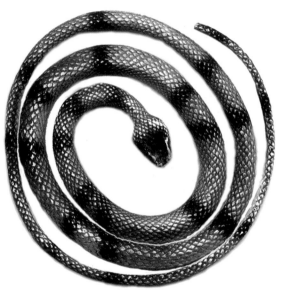

62 63

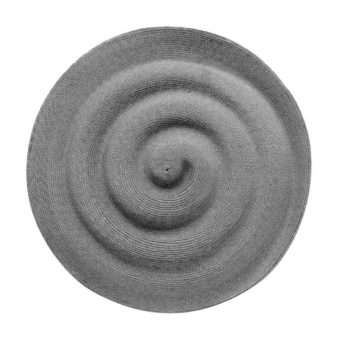

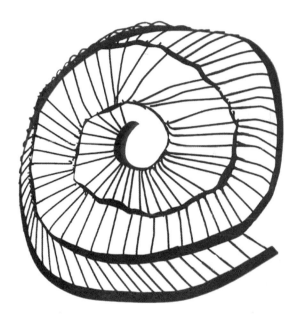

64

65

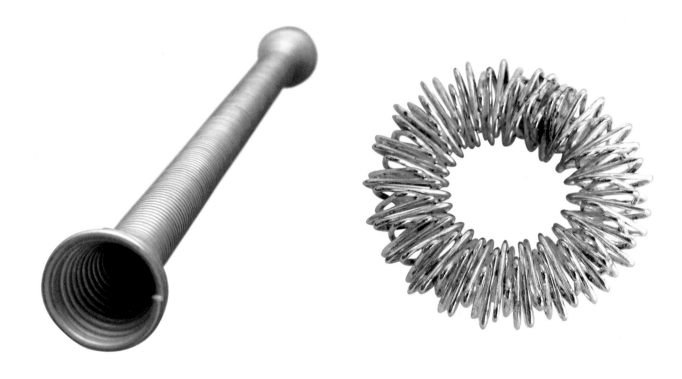

66 67

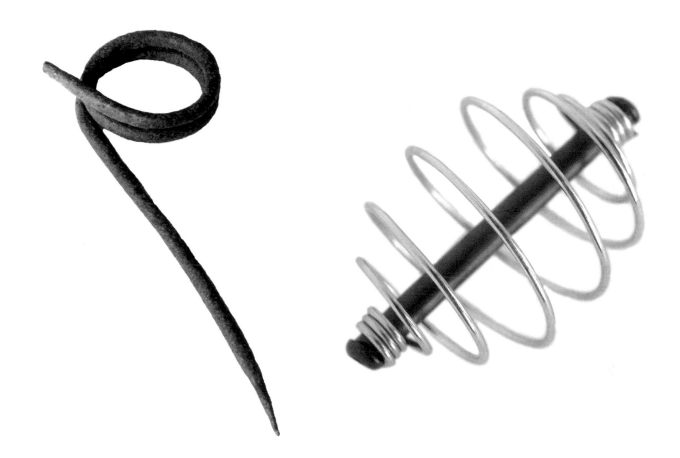

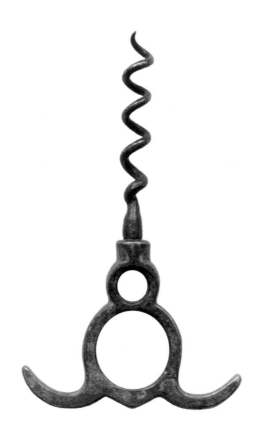

70

71

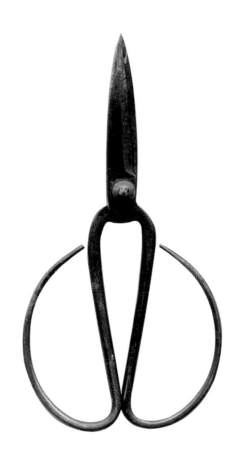

72

73

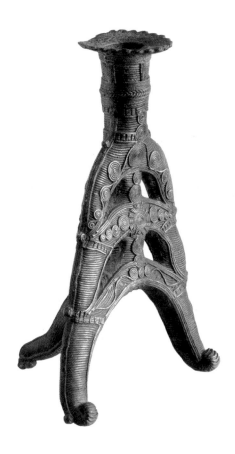

74

75

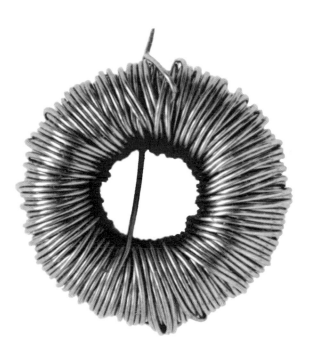

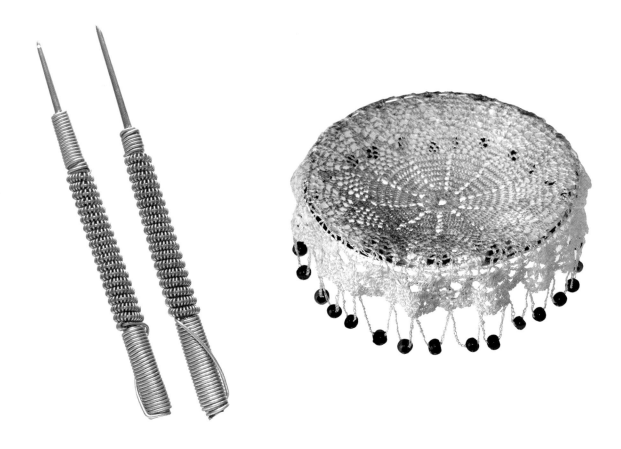

78 79

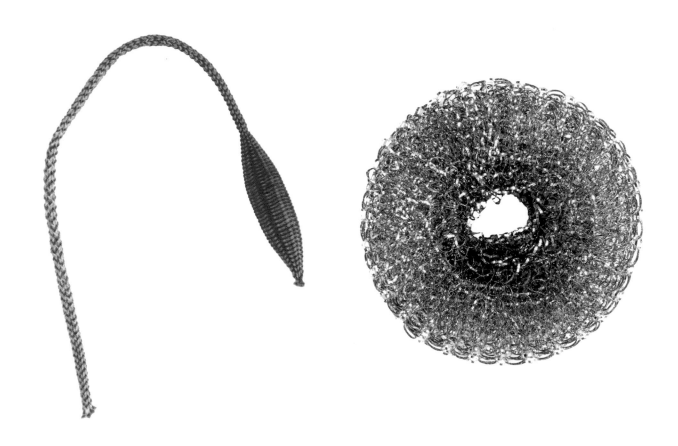

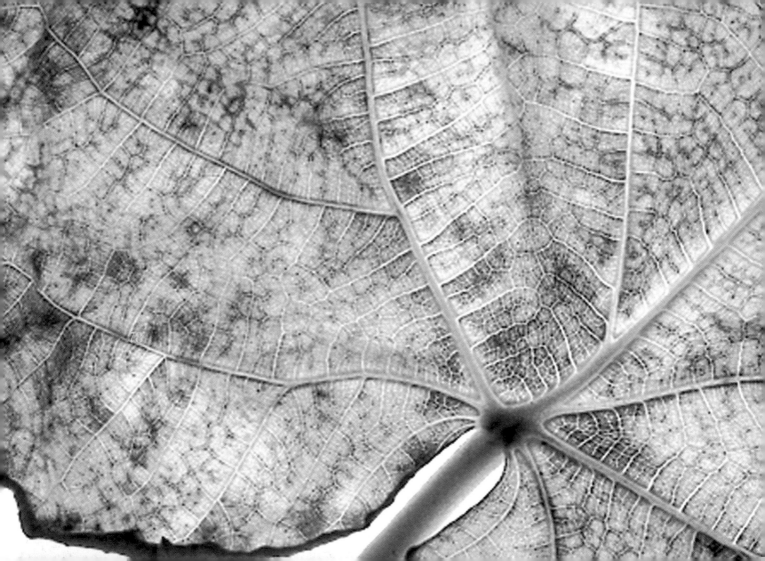

83 84

85

86

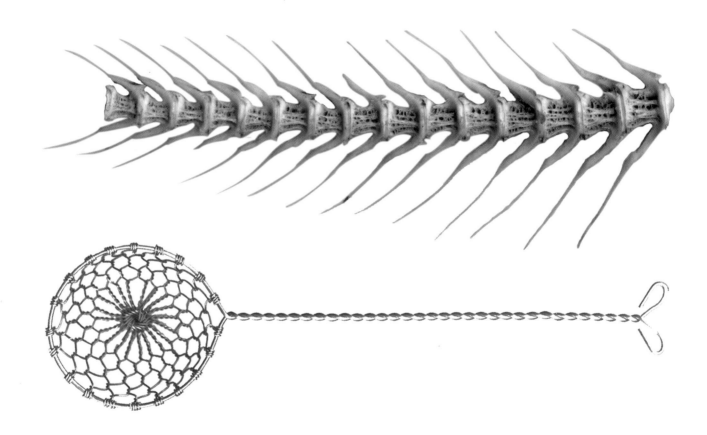

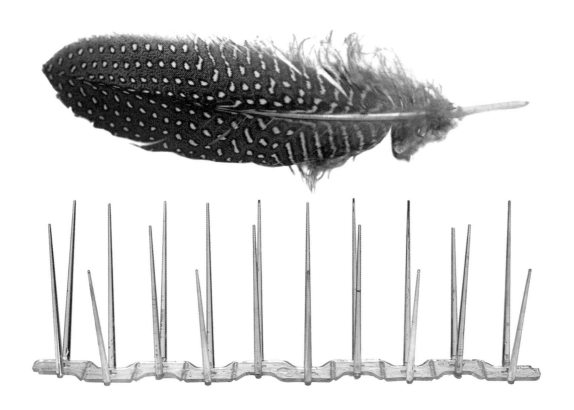

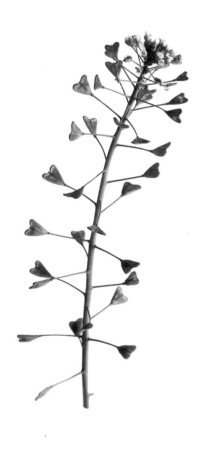

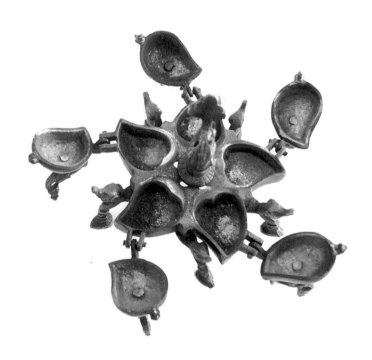

91 92

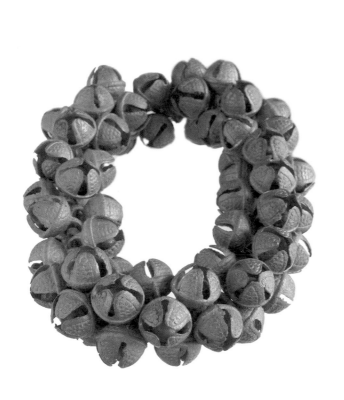

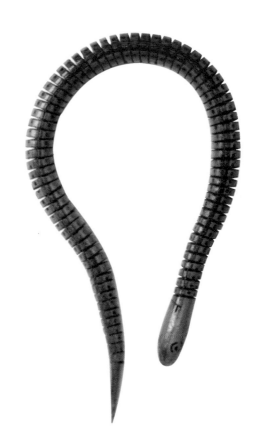

93 94

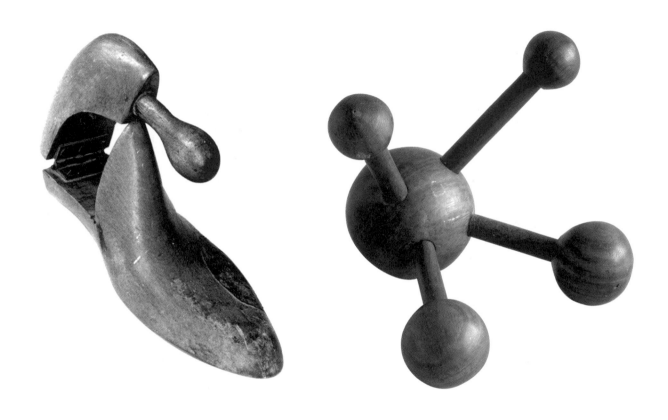

95　　　　　　　　　　　　　96

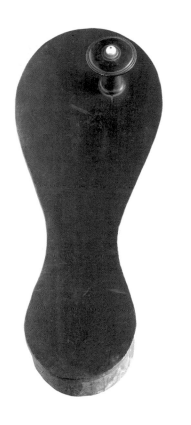

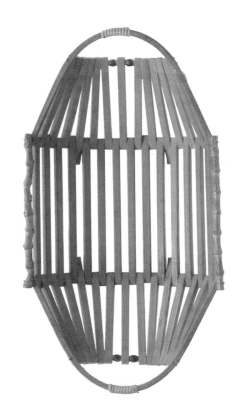

97 98

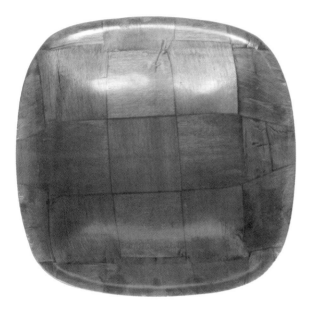

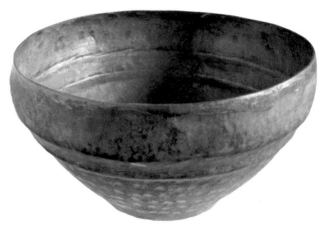

99 100

101 102

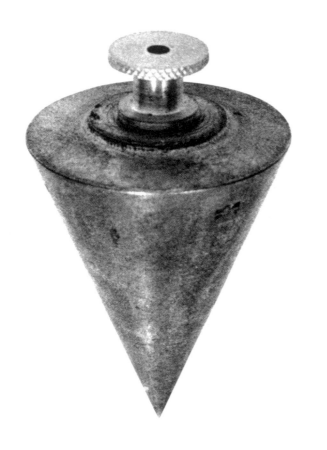

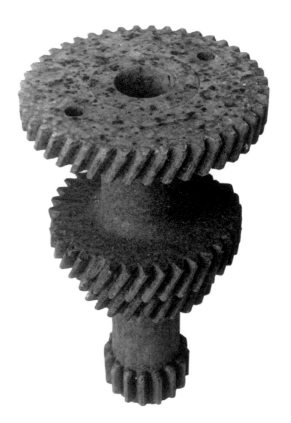

103

104

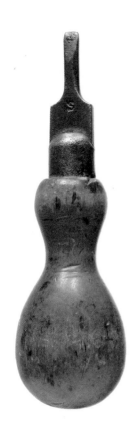

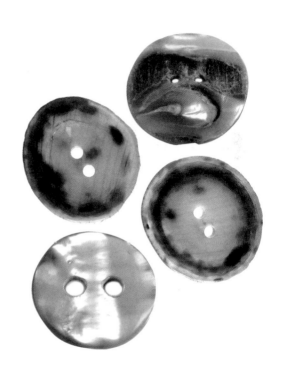

105 106

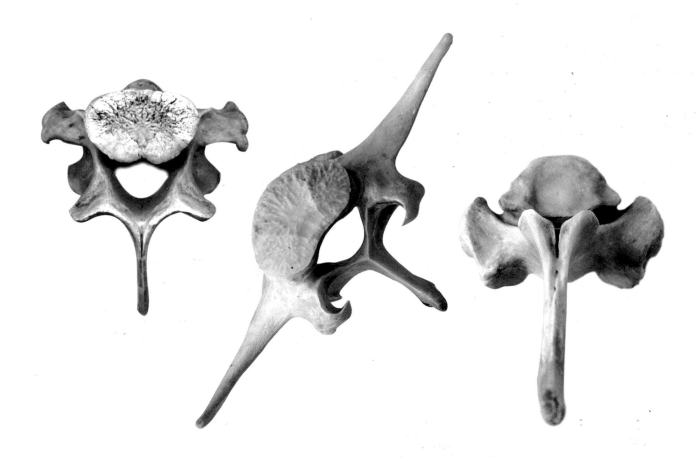

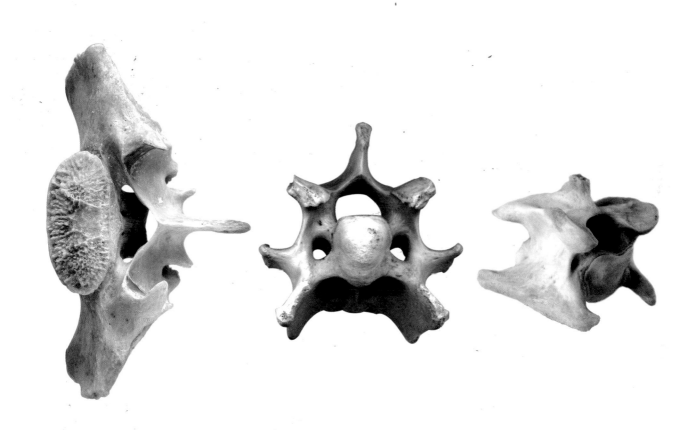

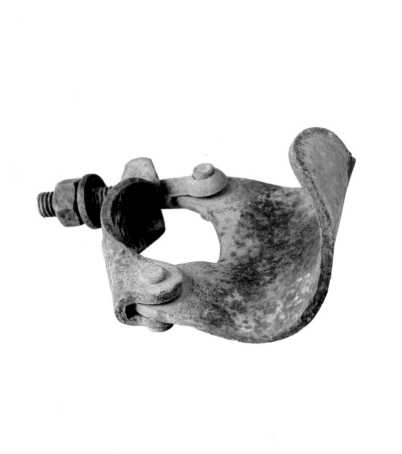

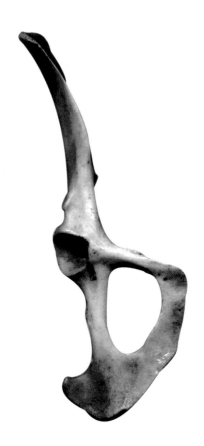

108 109

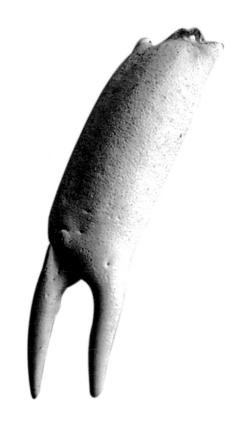

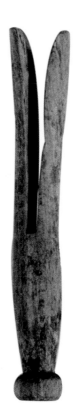

110

111

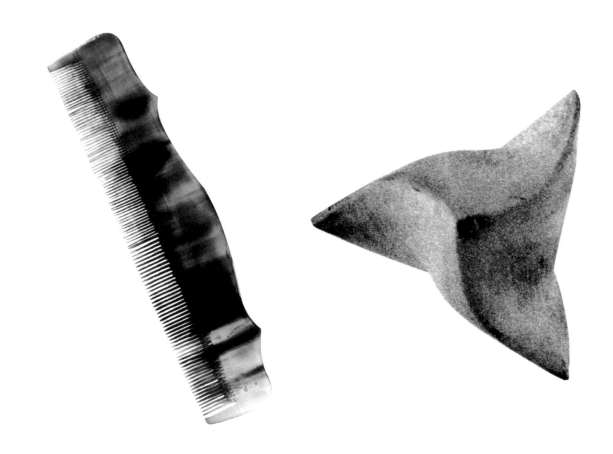

112 113

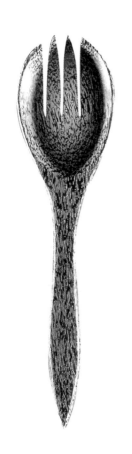

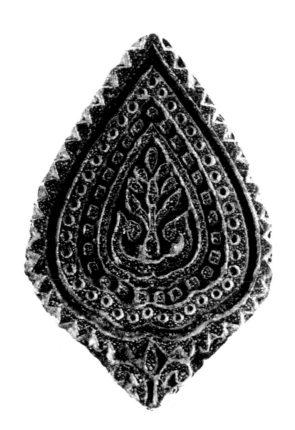

114

115

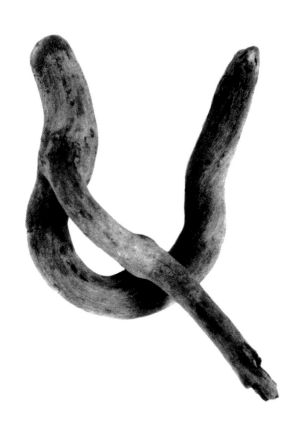

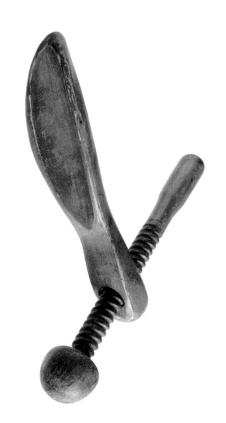

116 117

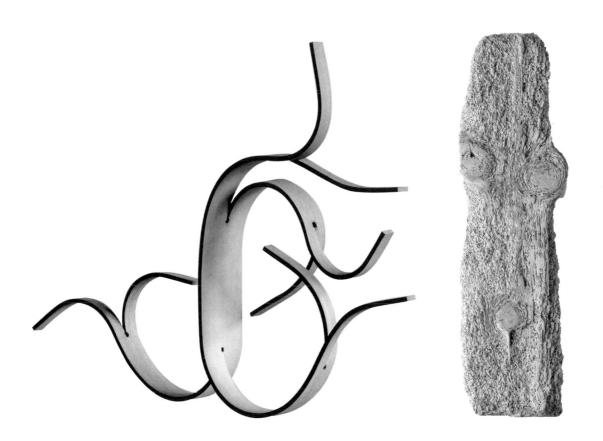

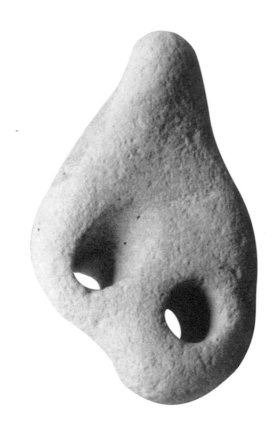

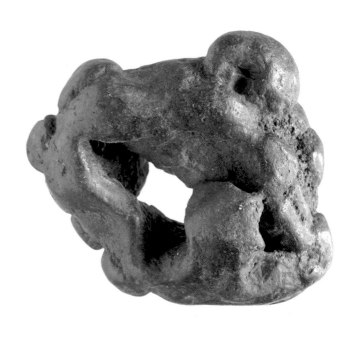

120 121

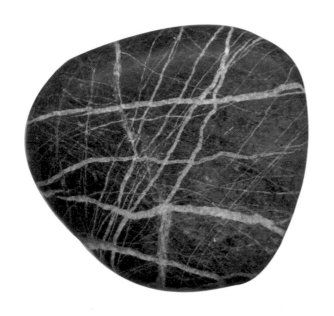

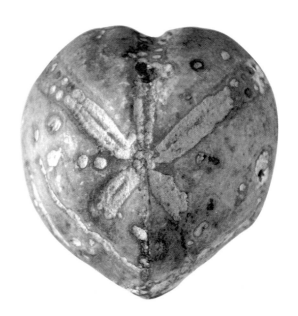

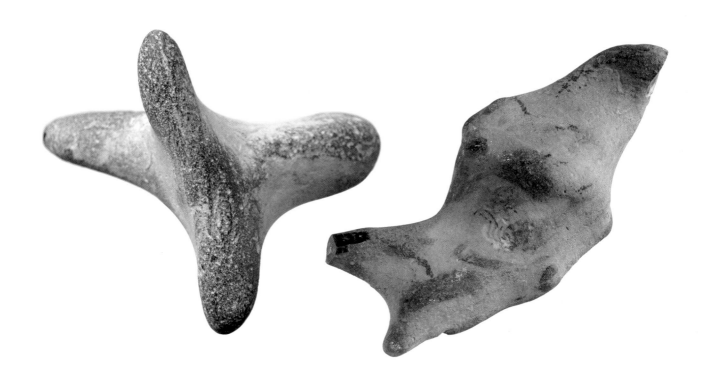

124 125

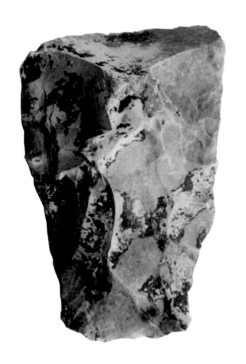

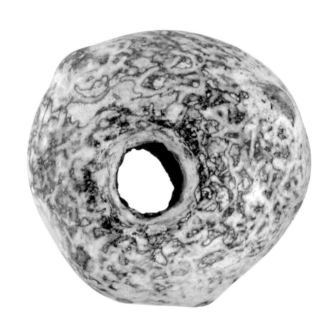

126

127

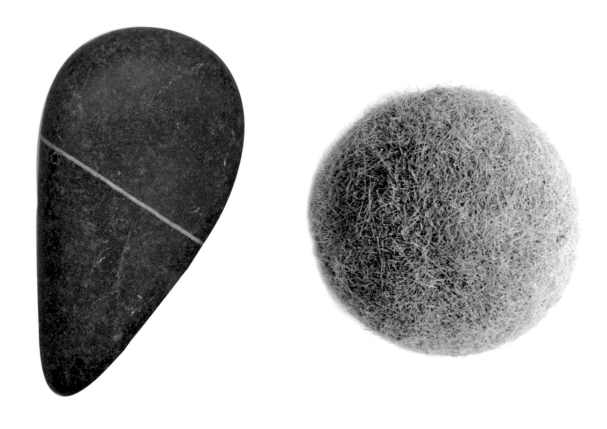

128 129

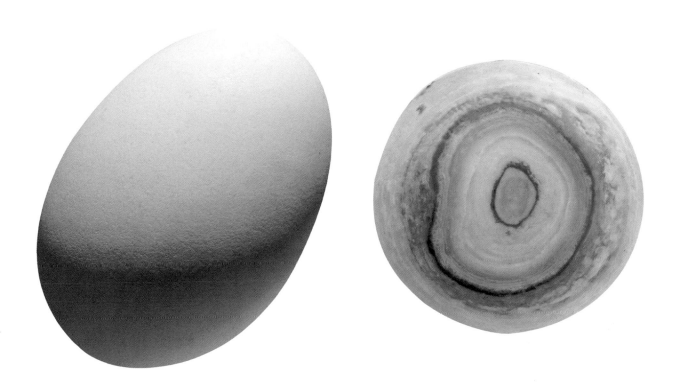

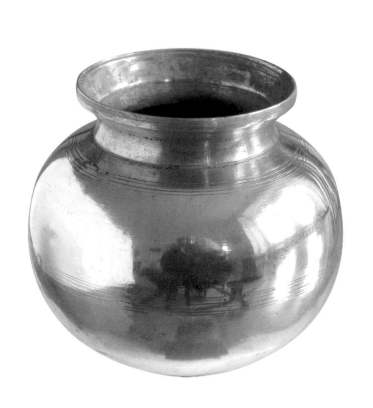

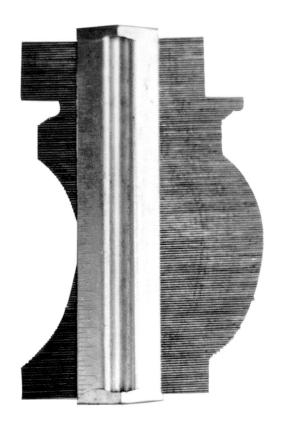

132

133

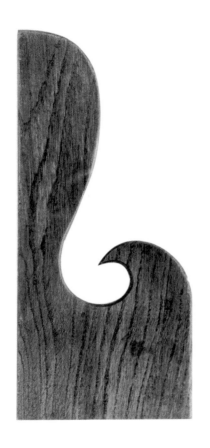

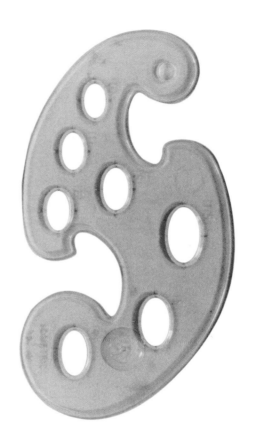

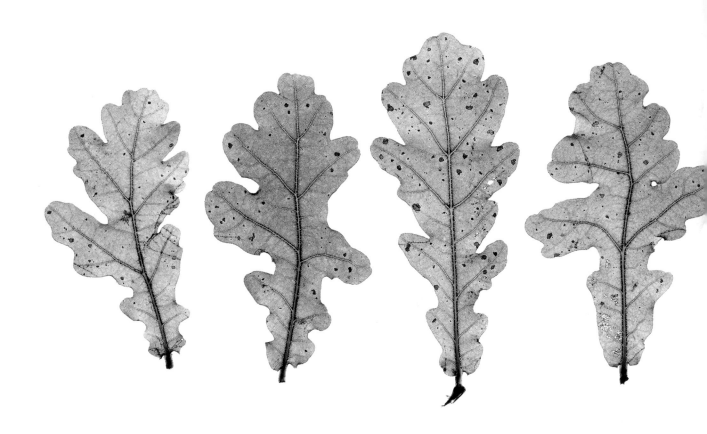

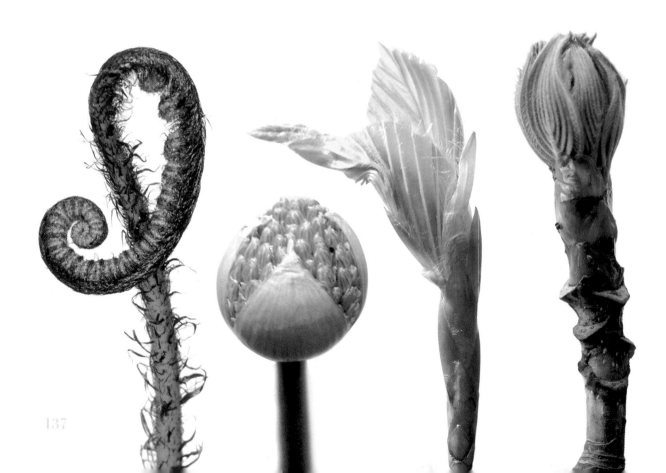

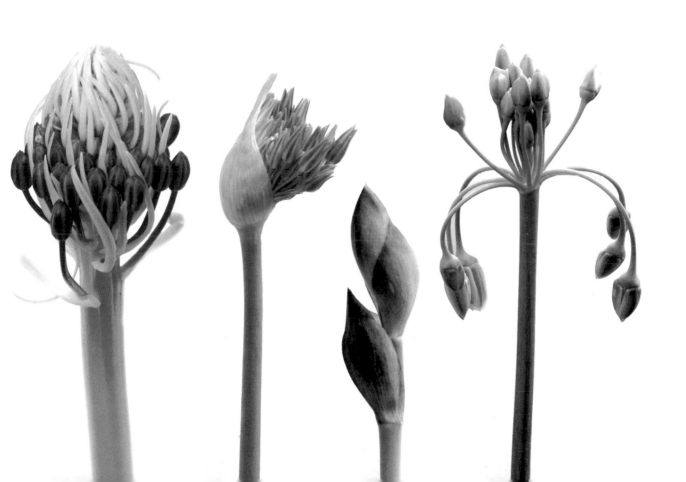

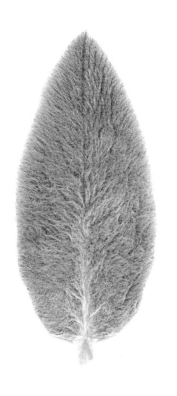

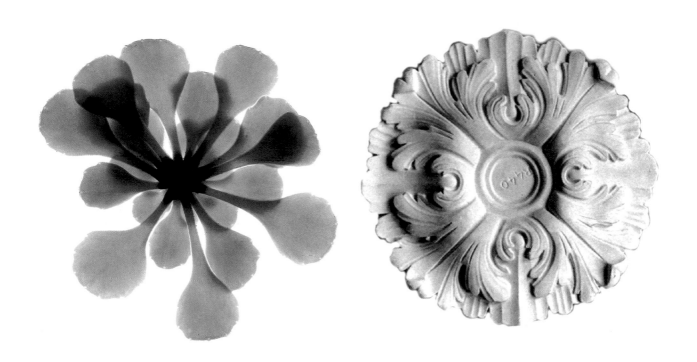

142 143

146 147

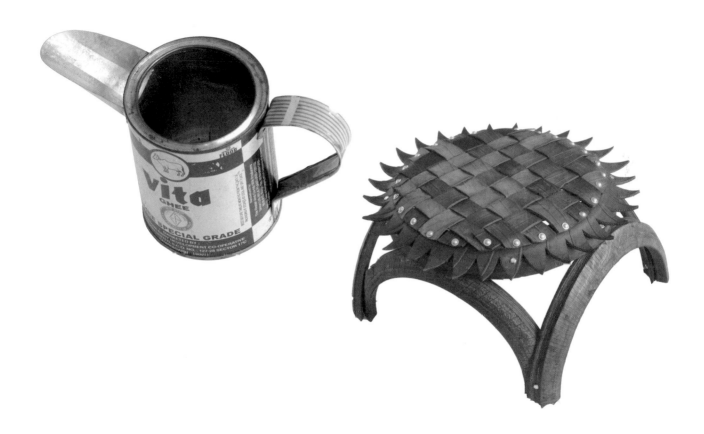

148 149

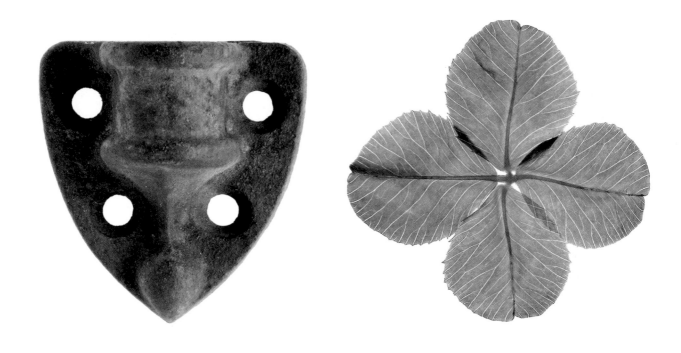

151 152

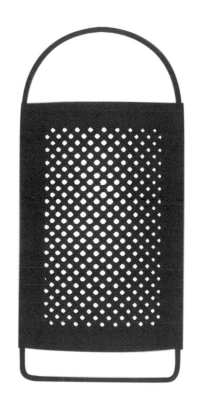

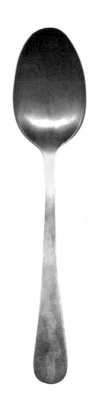

153

154

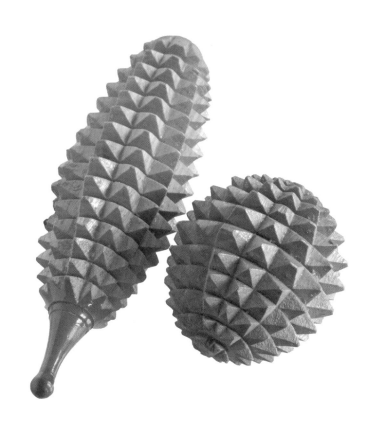

155

156

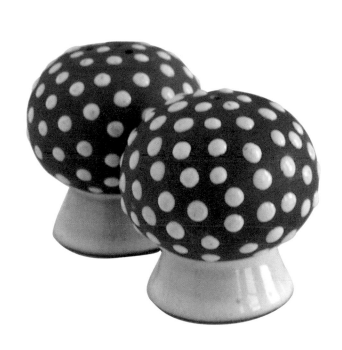

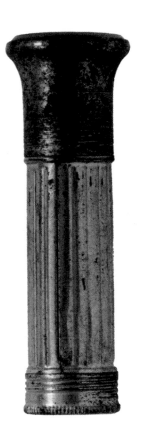

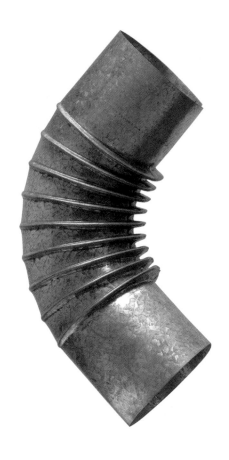

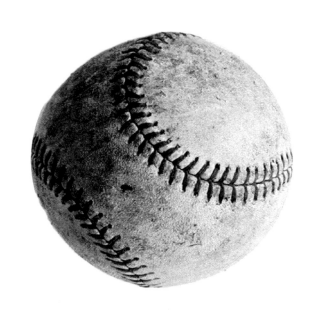

159 160

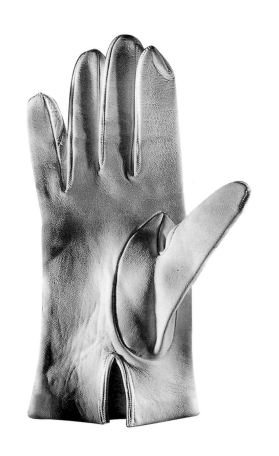

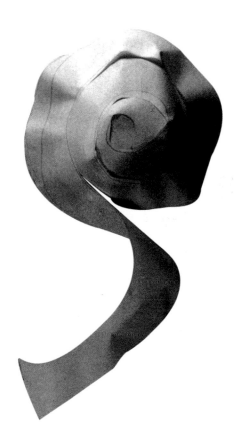

161

162

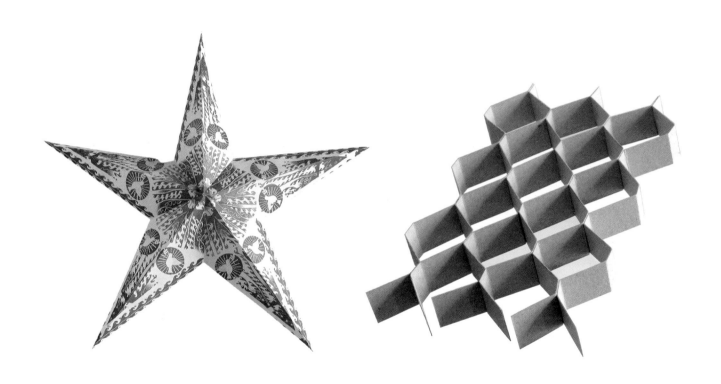

163 164

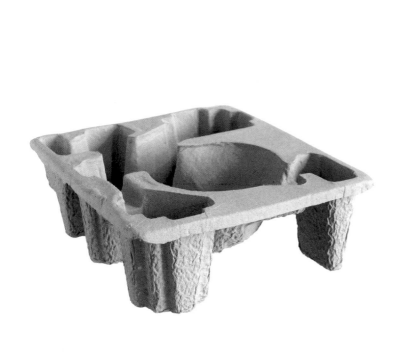

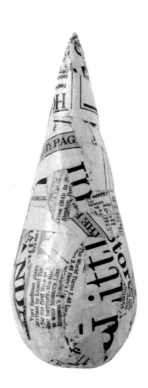

165

166

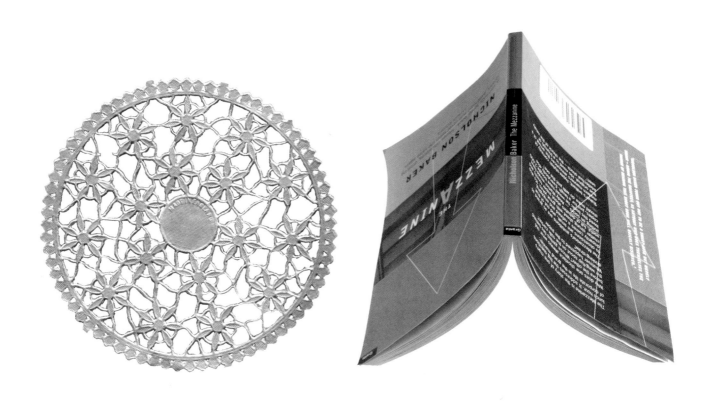

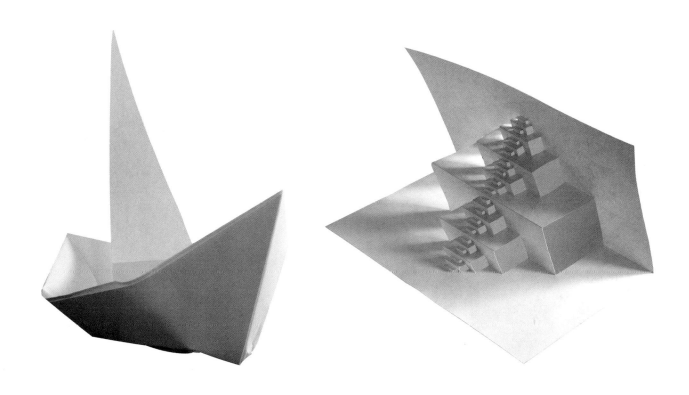

169

170

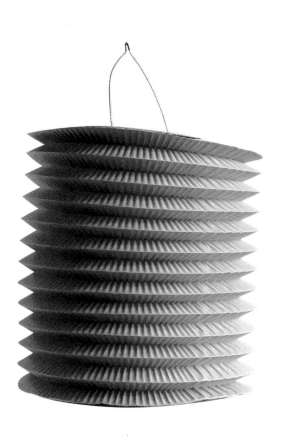

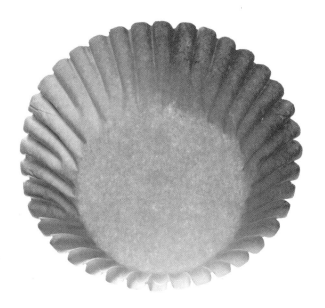

171

172

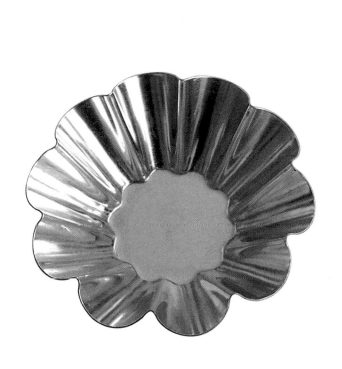

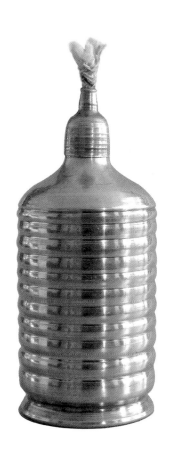

173

174

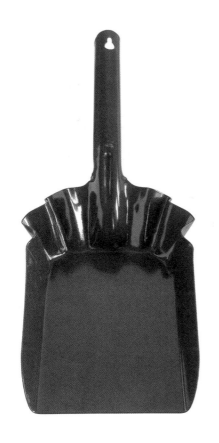

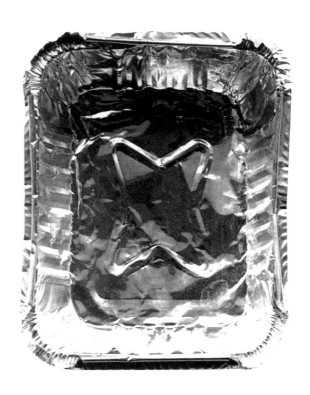

175

176

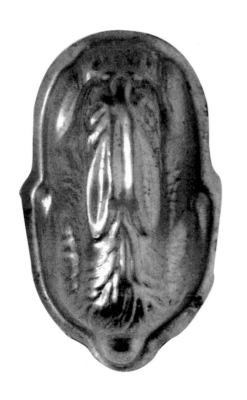

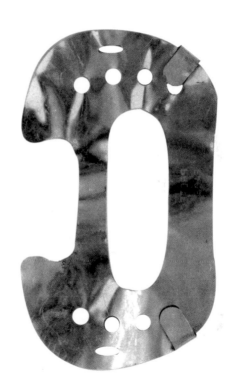

177

178

179

180

181 182

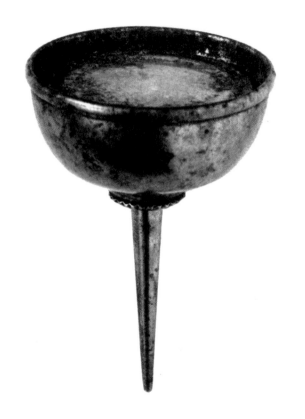

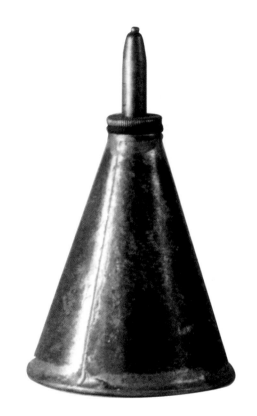

183 184

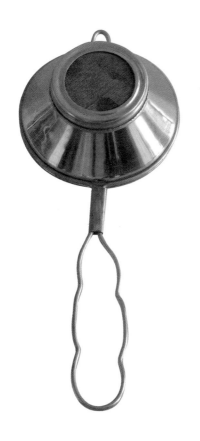

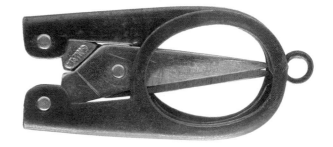

185 186 187

188

189

192 193

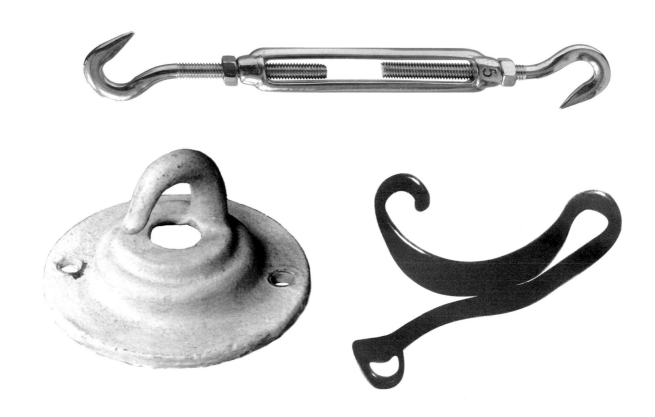

194 195 196

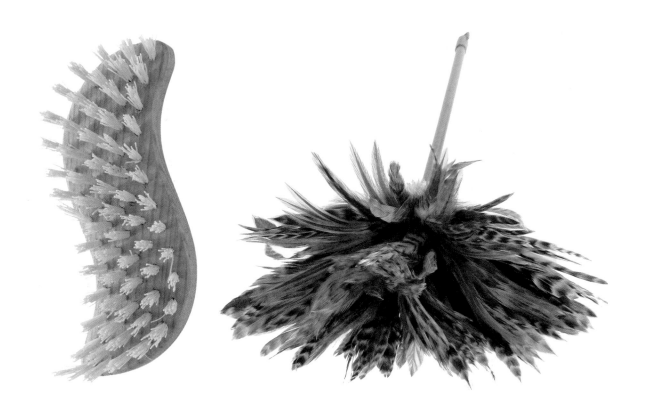

197 198

199

200

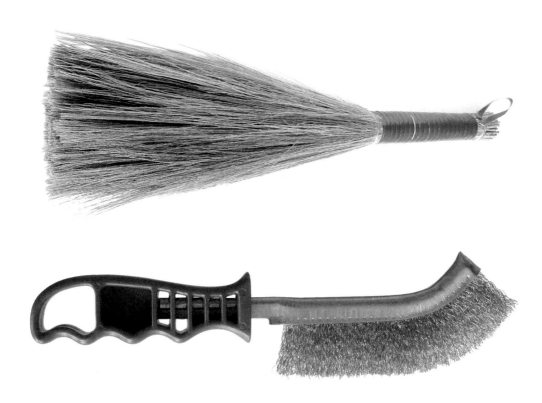

201 202

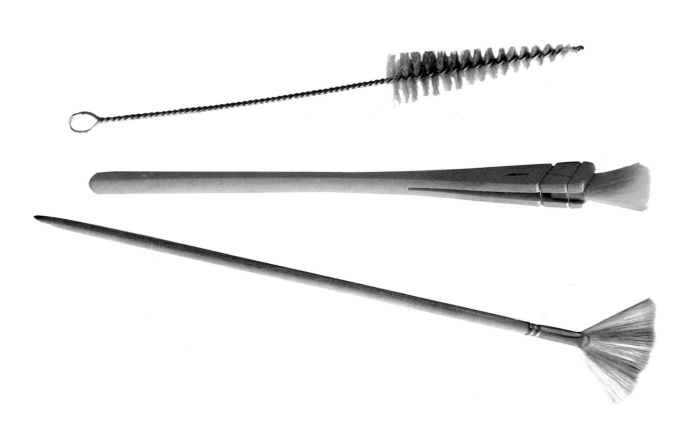

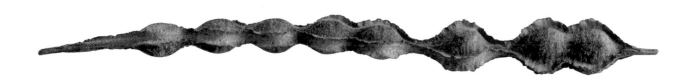

208

209

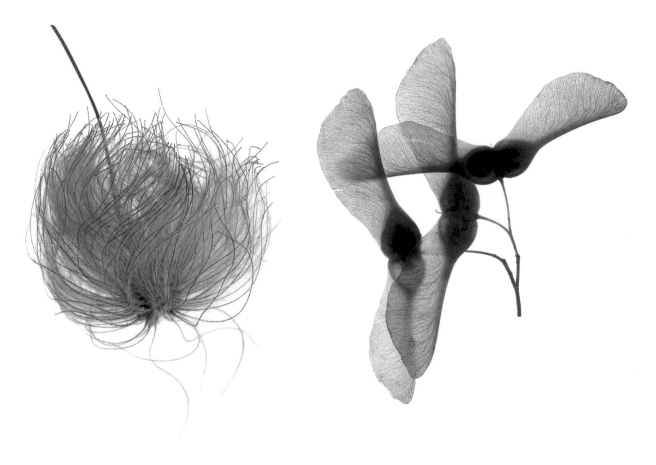

210

211

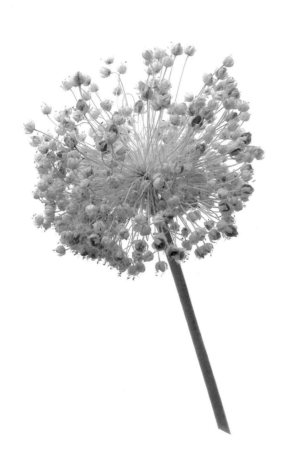

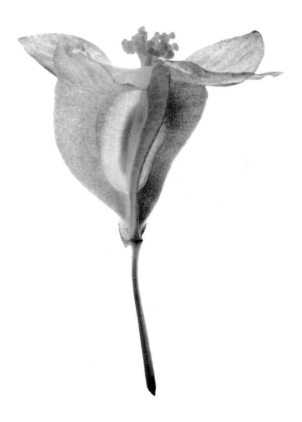

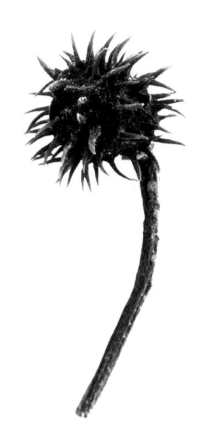

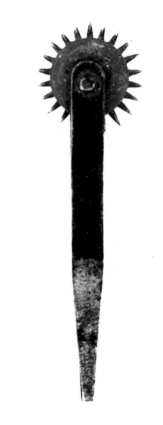

214 215

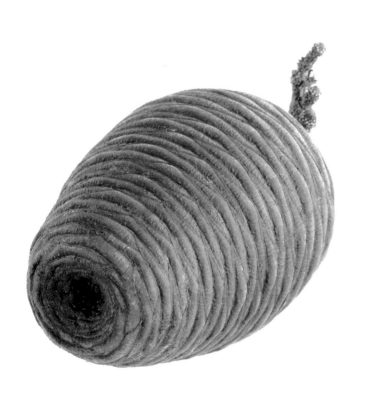

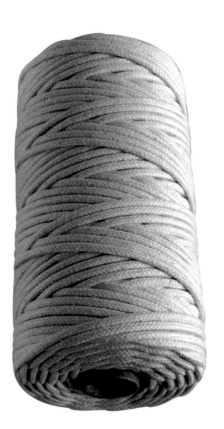

216

217

218

219

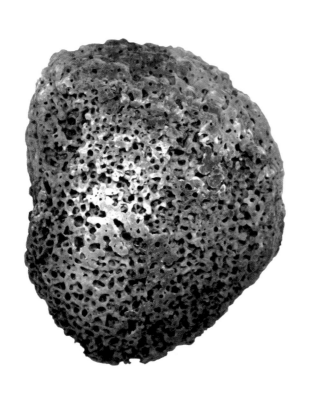

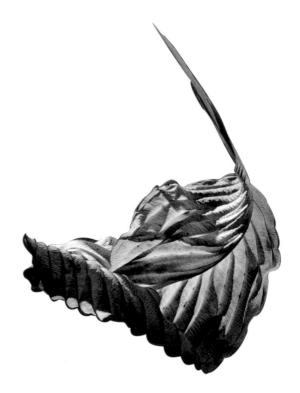

222 223

Notes

Measurements

All measurements are approximate and are in millimetres. They represent the size of box that each object would fit into – in other words, its longest measurements in three different planes.

Processes

Classification is a useful way of organising any body of knowledge; studying likenesses and differences between related phenomena always enhances understanding of their nature. I have divided all the making processes, both the handmade and the manufactured, into six different categories according to their material origins. This makes working out how something is produced much more simple. Each of the categories has a symbol, and one of these symbols appears beside the number of each object in the Notes. Sometimes the starting point is a bit ambiguous, for example does blown glass start as liquid or malleable? and does papier-mâché start as sheet or malleable?

Liquid
Starting from a material in fluid form – for example, clay, metal, plastic, glass, plaster, rubber or resin – and pouring, blowing or extruding it into a mould or former, then allowing it to solidify, usually by heating, cooling, exposing it to air or by adding a chemical catalyst.

Wire
Starting from a long, extruded or spun material – for example, metal wire, plastic, cord, cotton thread – and weaving, knitting, twisting, bending or tangling it into a form.

Malleable
Starting from a malleable material – for example, clay or annealed metal – and forming, throwing, moulding or bending it into shape, then allowing it to harden by drying or cooling.

Solid
Starting from a solid material – for example, wood, stone, nylon, steel – and carving, slicing or turning it into shape.

Sheet
Starting from a sheet material – for example, paper, sheet metal, woven fabric – and cutting, bending, joining, folding, pressing or perforating it into a form.

Natural
Objects formed by nature: plants, shells, bones or stones.

01

Aquilegia 24 x 35 x 24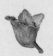

All the flowers on this page are funnel-shaped, enticing insects to visit them with their colour and their scent. They lure the insects to their interior to have them brush against the stamens and anthers, thus cross-pollinating with other flowers that the insect has visited. The natural objects in this collection share visual characteristics with the man-made: they all have a simplicity and beauty of proportion. Their inclusion is partly a homage to Karl Blossfeldt's *Art Forms in the Plant World*, which my father bought when he was an art student in the 1940s and which has been constantly rediscovered by artists and designers since its first publication in 1929.

02

Boat-seed tree flower 50 x 90 x 50

I found and photographed this dramatic flower in India without knowing what it was. I spent hours trying to identify it. Then I showed a picture of the flower to two Indian friends who both said it was very familiar, but they did not know the name of the tree. One of them told me that when he was a child he called it the 'boat-seed tree' because of the shape of its large seeds. This conversation started me thinking about all the children from different parts of the world playing with indigenous plants and flowers, learning games and names from their parents and passing them on to their friends and children.

03

Foxglove 14 x 28 x 45

To humans flowers are decoration; to plants they are reproduction. Functional design is often synonymous with bland design; flowers demonstrate how the opposite can be true. All flowers have evolved for the same purpose, to facilitate reproduction. They do so in slightly different ways according to their specific circumstances. Part of their function is to attract (specifically insects). Shouldn't the function of all utilitarian objects be to attract their targeted users?

04

Lily 40 × 65 × 15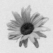

There are 270,000 documented species of flowers. Fossils of herblike flowers have been dated to 150 million years ago. It is not known how much flowers have changed since the beginning of man, although we now cultivate hybrids which can dramatically change the appearance of a flower species in just a few years. The first pictures of lilies were discovered in a villa in Crete dating from the Minoan period (1580 BC). Pictures of flowers cannot be relied upon for biological accuracy, because of course they are open to artistic interpretation.

05

Daisy 55 × 55 × 12

The daisy is the archetypal flower, a logo flower, and the flower that 90 per cent of people would draw if asked to draw a flower. This one is actually a member of the chrysanthemum family. All the flowers on this page are target-shaped, marked out to guide the insects to their centre for the act of pollination. It is interesting to compare them and observe the variations among what, at first glance, appear to be very similar flowers.

06

Anemone 52 × 52 × 10

Flowers have been a part of human life for so long that even the most humble people have constructed myths and legends around them. Anemones are widespread around the world: there are 150 species native to America, Japan, Europe and the wider Mediterranean. Roman legend has it that the anemone sprung from the tears that Venus shed when Adonis died. Anemones are unusual, as they have no petals; what appear to be petals are in fact sepals.

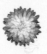

07

Chrysanthemum 95 × 95 × 60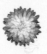

The chrysanthemum has been cultivated for 2500 years in China, where it is a powerful symbol of happiness, optimism and long life. It also has similar resonance in Japan, where there is a festival day devoted to it. Conversely, in Malta it is considered unlucky to bring chrysanthemums indoors because of their association with funerals.

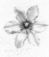

08

Clematis 60 × 60 × 12

I like the insect hole in this flower, which seems to emphasise its perfection, like a beauty spot. One of the profound differences between man-made objects and natural objects is the complexity of the detail. Viewed from a distance an object is seen as a form; getting closer you start to perceive detail. In 1995, Stuart Walker applied this principle to design, using the terms 'macro-simplicity' and 'microcomplexity'. This sort of duality is always found in nature; in fact, ever-finer layers of detail continue right into the cell structure and the DNA.

09

Primula 22 × 22 × 3

The radial symmetry of the flower is an archetype often found in design. It is the pattern of an explosion with lines radiating out from the centre.

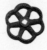

10

Stopcock handle 90 × 13 × 90

There is a lot of debate about the rightness, or proportions, of certain shapes. It is undeniable that certain shapes – for example, perfect squares – feel right. Whether this is because of their familiarity or whether there is something more mysterious and spiritual going on, I don't know. I think this stopcock handle has some of the same quality, maybe just because of its geometry or maybe

because of its relationship to the natural form of a flower. It seems at first an obvious functional solution, but on reflection I can think of many more simple shapes it could have taken.

11

Isopon pattern 260 x 30 x 260
I made this as a pattern for a metal candelabrum. It is cut from aeroply and then built onto with Isopon car-body filler.

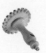

12

Gas burner 65 x 95 x 65
A cast-iron spare part from a gas stove which I discovered in the long-closed-up handyman's room at my local cinema, along with spare bulbs, gas-mantles, and tobacco tins full of nuts and bolts.

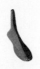

13

Shoe last 730 x 190 x 225
Made of cast iron and originally used by cobblers to nail shoes together. Shoe lasts have now commonly developed a new use as doorstops. Heavy, easy to lift by the ankle, and wedge-shaped at the toes, they are ideally suited to this new function. This alternative use also evokes a bit of symbolism through phrases like 'kicking the door shut' or 'putting the boot in'. I like the way an object very specifically designed for one purpose can be appropriated for a completely different one.

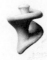

14

Shell fossil 45 x 60 x 45
Fossils are the castings of the natural world. I love this shell fossil for the beauty of its form but also for the associative memories I have of finding it. A few years ago we walked for hours to the end of a stony spit. There was a Napoleonic fort and a foot ferry marked on the map. Unfortunately, it wasn't the holiday season and we had to retrace our steps. I had new boots and blisters. That was when I found the fossil.

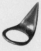

15

Wall flame 72 x 130 x 50

This is a simple aluminium sand-casting I made to hold a glass night-light holder on the wall. I modelled the pattern from car filler over a skeleton of bent sheet metal. I loved the fact that it could balance perfectly on its apex. Although that had nothing to do with its function, it meant it looked better – more balanced!

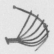

16

Grill 215 x 87 x 145

An unpolished simple aluminium sand-casting. A pattern is sandwiched between two boxes of compacted sand and then carefully removed to leave a cavity, which is then filled with molten aluminium via a sprue hole. This object was bought in a Spanish builders' merchant's, and I imagine it's to put over the top of a drainpipe to stop bird-nest building.

17

Bottle-stopper 33 x 43 x 33

This bottle stopper demonstrates a clever use of the physical properties of plastic. A simple ribbed structure fulfils two different functions on one small object: to squeeze into the neck of a bottle and form an air- and waterproof barrier, and to provide a non-slip handgrip when pulling the stopper out.

Plastic, which in the previous generation was a poorly made product and therefore earned the reputation of being 'cheap and nasty', has now evolved into a highly sophisticated material that dominates design at all levels. An example of this dilemma is the current, almost inevitable transition from natural cork for wine bottles to various manufactured solutions; the most popular being the self-sealing thermoplastic elastomer corks which still provide the traditional pop when opening, and require the ritual of the corkscrew, but without the disadvantage of possible fungal

contamination of the wine. Interestingly, the different cooling rates of the cork after injection moulding lead to a marbling effect in the plastic, which gives them an unintentional, almost rustic look.

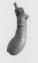

18

Doll's hand with gun 15 x 46 x 7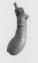
I dug this up in my back garden. It obviously predated Action Man, and there was something strangely compelling and innocent about it. I remember how much I loved cap guns as a child, delighting in their bang and smell. Plastic in the 60s was always stamped 'Made in Hong Kong', and tended to have mismatched seam lines and excess sprue.

19

Plastic sandal 55 x 156 x 40
Plastic sandals have been around since the 60s. Today's 'jellies' are soft and smooth, with transparent colours and floating glitter. The shoe is injection-moulded from PVC in two pieces: the hard-wearing, slip-resistant sole and the slightly softer, more bendy upper part. A pair of these sandals is expected to last for two or three years of regular use. One Brazilian manufacturer produces 80 million pairs of shoes per year, and they are all sold for a very downmarket price. Amazing!

20

Insulating plate 82 x 72 x 1.5
This component from the electrical industry is made from phenolic, laminated plastic constructed from superimposed layers of resin-impregnated paper, or from fabrics fused together under heat and pressure to form a homogeneous sheet. Fibreglass and Formica are examples of this type of material. Wood veneers can also be treated like this and pressed into bowls or used in boating for cleats, etc. Very strong, rigid, lightweight, non-conducting, non-corrosive and machinable.

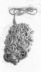

21

Plastic extrusion 160 x 360 x 50

Plastic extrusion 160 x 360 x 50

The last drippings of the day from an injection-moulding machine – like the random squirtings of an icing nozzle. Tom Dixon had the bright idea of using a redundant machine to squiggle open work containers using existing plastic bowls and bins as templates, thus cutting out all the expensive tooling and adding an element of the handmade.

22

Boilie hair stops 47 x 133 x 1

Leaving small plastic injection-moulded components on the sprues that are part of the making process is a good way of keeping small parts from being lost. The picture shows the enigmatically named 'boilie hair stops', the use of which is equally mysteriously described as 'to keep boilies, particles and other baits on your hair rigs during casting and retrieve'.

The most familiar examples of this type of product are Airfix kits. Airfix was originally the largest manufacturer of hair combs in England. They made their first model kit in 1948 – a replica of a new tractor being produced by the Ferguson company. The body was made from recycled fountain pens and the tyres from the rubber core of waste cable.

23

Belt buckle 37 x 45 x 1.5

These belt buckles were originally sold for the home dressmaker. It is strange how something can be so common at one time and then disappear in another age. I like to think that the dress belt buckles of the 20s, 30s and 40s have now been replaced in the accessories world by changeable mobile-phone covers, which in fact are incredibly similar to them – sheets of coloured plastic with holes in! Maybe the same factories could have manufactured both.

The casein plastic that these belt buckles were made from was very beautiful, with swirls of

colours often imitating horn and tortoiseshell. Casein was an early, semisynthetic plastic first produced in 1900. It was made from dried-milk protein in a long process requiring the material finally to be hardened by immersion in formaldehyde solution, sometimes for as long as a year. Production stopped in England in the 1980s, but it is still produced in New Zealand as a by-product of cheese-making, mostly for producing buttons.

Beer-can tie 113 x 3 x 140 ⬤

Another piece of plastic with holes in. A very clever idea that someone somewhere came up with, but like the plastic carrier bag something that environmentalists are not so happy about. It has been estimated that every cow in Delhi, India, has 300 plastic bags in its stomach; meanwhile, in animal-loving England there are outraged letters to the local paper about hedgehogs strangled by beer-can ties.

Dog toy 85 x 150 x 85 ⬤

This rubber dog toy has been carefully designed to accommodate all the different sizes of dog jaw. I once found another, similarly proportioned but differently detailed dog chew on the beach: from a distance of two metres I thought I had found an exotic sea creature; and after picking it up and reading the brand 'Kong', my mind boggled. It looked vaguely gynaecological. Many months later I saw someone throwing one for a dog and realised what it was.

Rubber is a natural material and has been utilised for hundreds of years. In the London Science Museum there is a Peruvian rubber ball which dates from 1650. The first widespread commercial application of rubber was in the making of rubber hoses (of all sizes – from surgical to firefighting). The widest use of rubber today is in the making of tyres, which have so obviously revolutionised the comfort and safety of travelling in wheeled vehicles. Disposing of redundant tyres is, however, a huge environmental problem. They have been extensively and imaginatively recycled as soles

for sandals, as doormats, planters and the like. More recently, tyres have been chopped up and made into safety surfaces for children's playgrounds. One suggestion for their reuse is to create huge undersea reefs of tyres to provide new environments for fish to breed in, in much the same way as shipwrecks have in the past.

26

Jar-top opener 110 x 55 x 110
A good-looking rubber product with an obscure function until you know what it is – and then it looks incredibly obvious. This one is bright red.

27

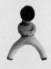

Horse rider 65 x 90 x 90
Produced by the same technology used for water bottles, this daring bareback rider originally rode a mechanical tin horse. The lightness and cheapness of the material was important, as he had to bounce up and down on a pole inserted straight through his body and head. I like the fact that he is so obviously a figure but is also two and a half circles – a logo man.

28

Surgeon's glove 210 x 120 x 2
Rubber gloves are made by dipping a hand form into liquid latex. There is a whole pre-operation ritual involved with these gloves: the surgeon washes his hands, operating the taps with his elbows; he then accepts the gloves, offered to him from their splayed paper packaging by the theatre nurse; then he pulls on the gloves, which are lubricated by talcum powder, by their edge from inside out. The whole procedure is performed like the steps of a dance.

Latex (the raw material of rubber) tapped from a tree is a commodity like gold or coal. A family in India with six rubber trees in their garden could take their latex to market and sell it at the world trade price. From there the latex might end up as surgeons' gloves or the similarly life-saving or

life-preventing condom. Rubber is ideal for situations where thinness has to combine with stretch-ability and therefore strength. In pre-rubber days, condoms were made from an assortment of very unsensuous materials including linen, animal intestines, tortoiseshell and thin leather. Amaz-ingly, a condom can hold 40 litres of air before bursting – equivalent in volume to nine gallons of water – and a large condom can be very carefully stretched over a postbox!

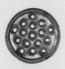

29

Stem-holder 110 x 30 x 110
Stem-holders like this were placed in the bottom of a vase of water to aid flower-arranging. They have now been superseded by oasis foam, which is green, crumbly and very unattractive.

30

Lampshade 172 x 114 x 172
Made by the process known as pressed glass, where a glob of molten glass is pressed between two moulds, the results are normally quite thick and robust. It is a process with lots of potential, as both sides can be pressed with different patterns. This process has a bad reputation as it is often used to produce crude imitations of cut glass.

31

Lemon-squeezers 140 x 80 x 140
This is an example of design that has become so anonymous, it's invisible, and yet it's a great piece of design. It works so well: squeezing the fruit, collecting and pouring the juice, and separat-ing the pips. It also looks good sitting on the table in the sun with the light shining through it!

32

Blown-glass bubble 80 x 95 x 80

Glass is made from sand. It is actually a liquid and flows extremely slowly; hence, very old windows are thicker at the bottom than the top. This hand-/mouth-blown glass bubble is glass-blowing at its most basic. A molten blob of glass is put on the end of a tube and blown into a bubble. In the days before plastic, glass bubbles like this were used as floats for fishing nets, though this one is merely decorative.

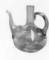

33

Salad oil bottle 200 x 170 x 120 ⬤

A skilful and graceful extension of the glass bubble.

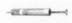

34

Glass syringe 20 x 145 x 20 ⬤ ◎

I bought this uncalibrated glass syringe from an army surplus store in London in the 80s. It is made very simply from glass tube, cork and cotton thread, and came packaged in a red cardboard tube.

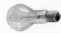

35

Light bulb 120 x 220 x 120 ⬤

Maybe the reason that the beautiful but fallible tungsten light bulb has not been completely superseded by fluorescent and plastic bulbs is the central role it plays in our iconography: how many company logos use the image of an illuminated light bulb to indicate bright ideas and enlightenment?

36

Glass bottles and glass measures 38 x 82 x 38 - 55 x 203 x 55 ⬤

Rows of bottles always remind me of the artist Morandi. It is interesting that he only painted

from a small selection of bottles that were themselves overpainted in increasingly dusty matt paint to hide the reflective glass and to turn them into solid objects. These hand-blown and hand-calibrated laboratory measures come from another era. I wonder how accurate they are. Presumably they were calibrated by pouring liquid from another hand-calibrated container – like Chinese whispers.

37

Plastic bottles e.g. 110 x 285 x 50 ◐

The huge variety in plastic bottles is thanks to computer-aided design: a bottle can be drawn on a CAD program and then a pattern is made automatically by a four-axis milling machine connected to the computer.

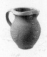

38

Jug 125 x 143 x 110 ◎

An archetype of a jug. The jug is to the potter what the chair is to the furniture designer – an object with certain fixed functions that can be endlessly reinvented. The jug has anthropomorphic associations, as the names of its parts illustrate: lip, neck, shoulder, belly, foot and handle. This jug is a latter-day milk carton; almost identical jugs to this were once thrown by hand at the rate of one per minute.

39

Insulator 55 x 203 x 55 ◎

In the pre-plastic days a lot of electrical fittings were made from clay. I found this in an abandoned woodyard. If you squint up at old telegraph poles you can spot all sorts of interesting thrown and turned ceramic insulators now superseded by tough plastic.

40

Plant pot 90 x 90 x 90 ⊚

A crudely hand-thrown plant pot which has survived from pre-industrial England. However, it is interesting to notice the precision of its proportions, which lends it an air of correctness that belies the apparently casual way in which it was produced.

 These pots are reminiscent of the disposable chai cups still used on the railways in parts of India. When I returned to India after a gap of twelve years (1991–2003) earthenware chai cups had almost disappeared from the railways, replaced by an endless trackside stream of plastic. Plastic replicas had also often replaced pottery water jars; the carefully evolved forms surviving, but the craft and material disappearing. The obvious advantages of plastic are its cheapness and lightweightness. On the other hand, clay vessels have an important cooling function and are more durable, aside from the rural employment they provide.

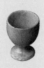

41

Eggcup 38 x 50 x 38 ◑

A relic from the last days of the Raj – a very utilitarian eggcup. This eggcup is an archetype of an eggcup – quite beautifully proportioned, but crudely made from a two-part mould. It is very tiny, made for an egg size that is no longer standard.

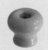

42

China knob 18 x 18 x 18 ⊚

I like the way that losing the scale of this knob can transform it into a piece of furniture. Ceramic with a relatively large mass-to-volume ratio is very robust: it would take a sledgehammer to break a toilet bowl, and this knob could be dropped on the floor without suffering any damage.

43

Handgrip 30 x 70 x 25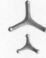

A form made by squeezing clay between my fingers. Clay is wonderfully malleable; it can be shaped in a very direct way and then used to form a pattern for other materials. This would make a very expressive screwdriver handle.

44

Kiln props 62 x 15 x 62

These different-sized kiln props are placed under ceramics in the kiln to stop glazes sticking to the shelves.

45

Gas element 70 x 35 x 45

Gas element from an early gas fire. Their function is to transmit and radiate the heat from the gas flame into the room. The fashion since the 90s has been for imitation coal fires with the flames flickering around everlasting coal. There is enormous scope for sculptor-designed gas fires with weird and fantastic or ethereally beautiful gas elements.

46

House brick 105 x 67 x 214

House bricks often have a 'satanic mills' type of image, but viewed with a fresh eye they are what can distinguish one area from another. Within living memory, bricks were made on site in makeshift brickworks. The holes in this brick are to offer a sort of mating point between the bricks and mortar.

47

Edging brick 220 x 45 x 150 ⊚

This edging brick, with its toffee-lustre glaze, was made in Lambeth for a local garden. Variations on these border edgings were as common in Victorian and Edwardian times as the cedar-shingle fence is now or the privet hedge was in the 60s.

48

Ventilation brick 215 x 62 x 215 ⊚

Another object with an alternative life option. Placed horizontally on my desk it conveniently displays a collection of pens and pencils.

49

Cracker 70 x 6 x 70 ⊚

I like the analogy between a lot of baked foods, on the one hand, and kiln-formed glass and ceramic products, on the other – mixed, pressed out, glazed and baked just like large biscuits. They meet at the meal table, though they are rarely mistaken for each other, of course.

50

Soda bread 200 x 190 x 110 ⊚

It is only comparatively recently that foams have been used as industrial products, but they've been around in baking for a lot longer. This bread is very similar in structure to the self-sealing foams used in car-door panels, wine-bottle corks and cavity insulation.

51

Crispbread 103 x 62 x 5

Every culture in the world has one or two traditional carbohydrate foods that are eaten daily. These form the bulk of the diet and tend to originate from the agricultural history of the region. In cold climates the staples are generally wheat-based, and in hotter climates maize- or rice-based. Scandinavia has a tradition of unleavened rye breads and crispbreads.

52

Iced gems 20 x 20 x 20

A childhood favourite. A clever bit of marketing and packaging design has changed them from party treats into everyday snacks. I love the contrast between the neat and formal biscuit and the frivolous topping.

53

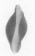

Pasta shell 17 x 14 x 28

Pasta, the traditional dish of Italy, is made from durum wheat. Pasta-making is now mostly industrialised, but the shapes originated from the handmade. The majority of pastas are extruded and sliced, sometimes with a little twist. The shell, or *conchiglia*, is a bit more complicated: it is cut from a sheet of pasta as a tessellation, pressed into a small dome, and then flicked back on itself to form a shell.

54

Volute shell 105 x 165 x 95

Shells are made from calcium carbonate and are produced as the outer skeletons of soft-bodied molluscs. There are 70,000 classified types of shell. They are hard and survive a lot longer than the creatures that once inhabited them.

55

Bivalve 50 x 50 x 15 ⊘

Seashells are divided into two main categories: the bivalves (made from two similar dishlike halves hinged together) and the univalves (snail-like). Bivalves have a formal similarity to a lot of man-made objects: books, purses, etc. Hinged shells were around long before any door hung from hinges.

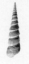

56

Turitella shell 30 x 120 x 30 ⊘

In Goa, where I found this example, Turitella shells were often appropriated by hermit crabs (soft-bodied crabs that take over the shells of dead molluscs to protect their vulnerable bodies). A very top-heavy and awkward home. Recently, naturalists working in the Pacific and Indian Oceans have spotted hermit crabs with plastic and glass homes. This could have an ecological significance.

57

Flat spiral 20 x 20 x 5 ⊘

A snail shell is a spiral that differs from other spirals in that each successive coil is larger than the one before. In 1638, the French philosopher and mathematician René Descartes named this the equiangular spiral. He observed that all lines drawn from the centre of the spiral will intersect its outer edge at the same angle. The equiangular spiral is the only mathematical curve that keeps the same shape while only growing at one end. As a snail grows it adds to the mouth of its spiral shell, thus gradually increasing its living space while keeping the same proportions.

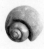

58

Snail shell 22 x 35 x 22 ⊘

This is a small shell I found in Goa. I liked the stone-carved look of it, which seems even better magnified by photography. Almost all snail-type shells wind clockwise. It is a rare and magical moment if you ever find a left-handed shell.

59

Romanesco cauliflower 120 x 130 x 110

I don't know the horticultural history of these extraordinary-looking cauliflowers. With its fractal geometry – the cauliflower breaking down into smaller and smaller identical units – it looks like a computer-generated plant. It also has a very manufactured colour – either purple or violent acid-green.

60

Sunflower seed-head 90 x 90 x 40

Packed with oily goodness! The seed-head is an example of two natural patterns: the equiangular spiral and packing. The centre of the flower is made up of many tiny flowers, or florets, which increase in size with their distance from the centre, the oldest and largest at the edges and the smallest in the centre. These mature to form fruits – the sunflower seeds that derive their angular, edged shape from the way they are packed so tightly together.

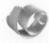

61

Wood shaving 33 x 25 x 17

Wonderful shapes, very evocative of the smell they produce. They remind me of Richard Deacon's laminated wooden sculptures.

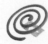

62

Mosquito coil 100 x 60 x 100

In a spider's web or a coil of rope each successive coil is the same width as the preceding one. This is known as an Archimedes spiral, after its discoverer. The mosquito coil is a very elegant little contraption; magnified, it would not look out of place in an exhibition of late 20th-century sculpture. Poised on its stand so that it can smoulder unimpeded, it is spiral-shaped for maximum burn time. Each spiral is configured to flat-pack snugly around another so as to minimise breakages. The fact that the smoke causes asthma is another matter.

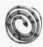

63

Toy snake 135 x 140 x 12

A souvenir of frequent visits to London Zoo and a satisfying toy. I often wonder about the 'artists' in China carefully modelling the plastic zoo and farm animals. If you look at them carefully, the skill and artistry involved varies hugely: maybe one artist hurriedly copies an existing model; while another goes on safari and sketches the animal in its natural habitat, before modelling twenty variations and then finally choosing the one that fully captures the animal's essence!

64

Straw hat 330 x 70 x 330

A straw hat is one of those old-time things, like seed-cake, that you read about in books, but turn out differently when you see them. Straw hats can be incredibly refined. This one has been constructed like a coil pot and then steamed into a larger-scale spiral.

65

Fruit bowl 248 x 281 x 205

This fruit bowl was the result of a student project at the Royal College of Art, London. Using the spot welder, we had to design and make an object to hold fruit. When we had finished we were told to draw it with complete accuracy, in plan, elevation and section. I would normally have been conscientious, but in this case I had to admit defeat. It seemed a fruitless task, if that isn't too terrible a pun. A set of verbal instructions would probably have worked just as well.

66

Plumbers' spring 25 x 300 x 25

This is a plumber's aid for bending pipes without splitting them. The pipe is inserted inside the spring before being bent. The spring diffuses the bending force, helping to bend the pipe evenly.

Springs have been made the same way for 300 years. Most are made from alloys of steel, the

most common being oil-tempered wire. There are three basic categories of spring: compression (making shorter) – for example, a spring in a bed mattress; extension (making longer) – for example, a spring for weighing fish or a spring on an Anglepoise lamp; torsion (twisting) – for example, a spring on a letterbox or a clipboard.

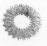

67

Finger massager 23 x 7 x 23

I bought this in India. It is a phenomenal little construction: handmade from silver, sprung wire, it is folded into a triangular helix which rotates a third of a side per loop. There are approximately 300 bends. When you roll it up and down the lengths of your fingers, it gives a very firm and slightly prickly massage.

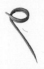

68

Torsion spring 80 x 255 x 33

I found this rusty but graceful, gestural spring on the beach in the Isle of Sheppey. The whole beach was still littered with the debris of the Second World War, even in the 1980s, and this spring was probably once part of an army vehicle.

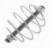

69

Bait spring 22 x 35 x 22

A surprisingly elegant little gadget for fixing a lump of bait to a line to attract the fish to the hook. Fishing-tackle shops are a great hunting ground for weird and wonderful inventions; in my local one I found 'three-bladed worm cutters' – for saving time when cutting up worms! And 'pop-up tutti-frutti-flavoured sweetcorn and dog biscuits', made from flavoured plastic and designed to float near to your fishing line to attract fish to the vicinity. Both these items were subsequently included in Thomas Heatherwick's collection for the Design Museum's Conran Bequest 2003. Heatherwick is interested in objects which show evidence of inventive thought processes; he

says he likes to imagine the board meetings that result in the decision to manufacture a pair of scissors specifically designed to cut up worms, or other equally improbable products.

70

Corkscrew 115 x 72 x 12

The corkscrew or spring-shaped spiral is known as a helix. Each loop of the curve is identical to the last, thus it grows in a vertical rather than a horizontal plane. The most famous example of this in nature is the double helix of DNA.

Opening a wine bottle is a mechanical challenge with a rich reward, for which there have been numerous ingenious and witty solutions. This is a very simple solution operated by two fingers and a thumb. Unlike some corkscrews, which can be conundrums, this one more or less tells you how to use it.

71

Hobby drill 180 x 25 x 25

A small Archimedes drill, designed for model-making, which can be used to make very small boreholes. This is the simplest form of hand-drill, operated by pulling the spindle up and down the shaft. It is a direct design descendant from the Archimedes drill described by Vitruvius in the first century BC, used to lift water from the ground. The advantage of the spiral drill-bit over a cylindrical borer is that it lifts the drilled material up and out of the hole.

72

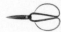

Chinese scissors 95 x 170 x 18

I always think forging must be related to calligraphy: it has the same grace and attenuated strokes. Such gradually tapering forms are often found in botany, and I think these were the formal relationships that Karl Blossfeldt was exploring in his photographs of wild plants.

73

Lock 70 x 110 x 8

A sort of inverted padlock with a tiny lock and an outsized hasp. I'm not sure of its original purpose, but I think it must have been custom-made. The shape on the key is echoed by the shape of the hasp, which doubles as a handle.

74

Dhokra candlestick 135 x 190 x 90

Dhokra is a very old method of lost-wax casting which is still practised today in India. In the past it was found in various other cultures: the cast-gold filigree earrings of ancient Columbia (around 1000 AD) are one example.

The wax thread is wound around the clay core in the same way as a coiled pot is made, but instead of being smoothed off the wire effect is used decoratively; it also uses the smallest possible quantity of metal.

This candlestick was made for me by tribal craftsmen in the village of Sadeibirani in Orissa, India. It was fascinating to see how their cultural references affected their interpretations of my drawings. Where I had been thinking about forms similar to unfurling ferns, they interpreted these as curling elephants' trunks.

75

Dhokra door handle 92 x 38 x 84

This handle reminds me of my favourite activity during my brief life as a student nurse – doing the bandages! In this case, around five bronze fingers which interlace with the flesh fingers when the knob is twisted.

76

String 55 x 85 x 65

How to store string is an age-old design problem. The traditional ball of string works brilliantly, but only when you have been let into the secret that it unravels from the middle.

77

Electromagnet 23 x 10 x 23

I bought this mini electromagnet from a tiny shop in Tottenham Court Road, called Proops. It was completely different from all the shops around it, which all sold TVs, cameras and hi-fis (this was in the pre-computer days). Proops was hard to find. I always had to walk up and down the street several times before it seemed to appear, as if by magic. It sold little plastic bags of all sorts of utilitarian but slightly useless components such as springs, mini pulleys or rubber bungs.

78

Wire chain-stitchers 6 x 95 x 6

An ingenious handmade sewing needle bought in Rajasthan, India. The needle is rolled in a long thin cone and the wire handle wound around it. The needle is used to embroider shawls, clothes, bedspreads, etc. It has a hole at its tip and is pushed in and out of the fabric from one side, joining together a chain of loops. I imagine this might have been how very early sewing machines worked.

79

Crochet pot cover 250 x 250 x 5

An idea from the pre-fridge, pre-Tupperware days to protect food and drink from flies. This initially flat or formless object assumes a shape when it is draped over a container and weighted with the glass beads. The Victorians also starched crochet to form little baskets for sweets or biscuits. Maybe this influenced Paolo Venini's famous glass-handkerchief vase from the 50s or Droog's resin-soaked crocheted chair.

80

Rope end 18 x 300 x 18

I found this intriguing turquoise piece of detritus on a pile of rubbish in a fishing harbour. It looks like a snake that has swallowed a gherkin, and my guess is that it is designed to help you get a grip on the end of the rope.

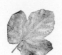

81

Pan scourer 85 x 85 x 30

An intriguing and clever piece of everyday kitchen equipment made from a knitted sausage of copper wire or brightly coloured plastic rolled around to form a doughnut.

82

Fig leaf 170 x 140 x 1

Branching is a system or pattern often found in nature. Think of the branches and roots of a tree, the veins in the leaves of the same tree and the veins that carry the blood around our bodies. A branching pattern is an efficient way to reach all the points in a large area while moving along the shortest distance. As is the case with most patterns in nature, it has been commandeered by the manmade world, in particular by the road system – a very practical application – but also for decorative or symbolic purposes.

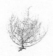

83

Tiny bush 120 x 165 x 70

I found this miniature bush blowing in the breeze of a British bog. The resistant cellulose fibres outlived the green to form a bush skeleton. The roots of the plant appear to have been quite minimal, whereas in general as much of a tree's structure exists below ground as above it. The seeds of the sea cabbage, another bog plant, are dispersed when the plant to which they are still attached is blown and bounced across the ground. Maybe this little plant reproduces itself in a similar way to the notorious desert tumbleweed.

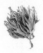

84

Sponge 155 x 165 x 60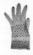

Sponges have been around since prehistoric times. There are more than 9000 species of sponges, and they can grow to an enormous size. They are made up of individual celled organisms that cooperate to perform the simple functions that keep them all living. The cells are all mobile and most can change their structure and function. Flints are fossilised sponges.

Dutch designer Marcel Wanders soaked a sponge in porcelain, fired it and used it as the base for a vase.

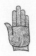

85

Wax stencil 130 x 70 x 1

This wax stencil is used for henna hand decoration for Hindu weddings. The stencils come in a variety of designs and in child and adult sizes. All the designs are based on a branching lattice that reminds me of the blood vessels inside the hand itself.

86

Crochet glove 180 x 100 x 3

A hand is a part of the body and therefore not an object in its own right. However, it has spawned a multitude of hand-shaped objects.

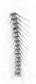

87

Fish vertebrae 80 x 150 x 10

Bones are the hard parts of animals, fish and birds, the parts that would be designed by a structural engineer. The backbone of the fish protects its spinal column and allows the fish's body to flex as it swims. It also anchors the ribs, which in turn are spanned by the skin and the muscles, and thus the internal organs are protected.

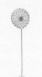

88

Sieve 60 × 225 × 40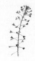

A faultlessly made wire construction a bit like expanded wire knitting or a Celtic knot. Celtic knots are the intricate motifs which illuminate the texts of manuscripts such as the 7th-century Lindisfarne Gospel. They are a graphic representation of entanglements and interlacing, spread flat and spaced out to make them more intelligible.

89

Feather 190 × 55 × 20

A basic structure adapted to many different functions: aerodynamics, camouflage, courting rituals, waterproofing, body-temperature control, intimidation, and differentiation from other species.

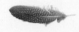

90

Pigeon deterrent 140 × 335 × 110

These plastic spikes are a cheap but functional solution to the problem of pigeons roosting on window-sills and ledges. The spikes are very pointed, but slightly bendy to keep them from snapping. They are strategically arranged for maximum physical impact to a pigeon breast, and transparent for minimum visual impact on human sensibilities.

91

Shepherd's Purse 18 × 80 × 18

This little weed derives its common name from its heart-shaped seeds, which look like tiny purses.
 Repetition is a powerful aesthetic: for example, the rhythm of an avenue of trees, or a row of columns, or rounded hills getting gradually smaller in the distance. Repetition in small objects can often give things a deceptive feeling of complexity. I like the repetition of handmade elements that are not exactly the same: a chandelier with hand-blown shades or the pattern on a hand-woven rug.

92

Cast-bronze temple ornament 135 x 85 x 135 (open)

For storing the coloured paste used to anoint the foreheads of the temple worshippers. This picture shows it with all the little pots open. It makes a very satisfying pattern which at first glance is complex and hard to understand, but which after a few moments resolves itself into a simple repetitious design with radial symmetry.

93

Cast bells 115 x 165 x 35

Crudely cast in two parts from a brass alloy, the four-leafed bell is closed around the seedlike clapper. The noise produced by the bells en masse is a whispered tinkling or rustling rather than a ringing or a clanging.

94

Wooden snake 380 x 20 x 20

The almost uncanny thing about this traditional toy is that if you hold it by the tail and gently wave it from side to side, it wriggles in your hand almost exactly like a real snake. It must be because the wooden segments joined by a glued strip of leather replicate the ribs and backbone of the living snake.

95

Shoe last 80 x 240 x 110

In the days when town cobblers made a new pair of shoes for everyone every year, they would have had personalised lasts such as this one (complete with bunions) for all their various customers, and would simply shape the leather around them when the time came.

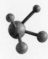

96

Head massager 110 x 105 x 140

What at first glance looks like a scientific model illustrating cell connections is in fact a head massager. The larger sphere fits very satisfyingly into the palm of your hand as you walk and roll the other four spheres over your skull and the back of your neck (not quite so good with long hair!).

97

Sandal 88 x 245 x 60 ⊗

The base of the sandal is carved from a single piece of fine-grained wood; the toe post is turned from horn and fixed underneath by a hole and toggle. I bought this single shoe in a street market, but it seems from the faded handwritten inscription underneath – 'Shoe from the South Seas, lent by Mrs A. Williams' – that it was once in a museum.

Once the ubiquitous footwear of the developing world and cyclically the fashion footwear of the developed world, the sandal is the shoe in its simplest form. There is something relaxing about a shoe that is so simple to understand.

98

Japanese basket 185 x 60 x 327 ⊗

Made of repeated elements of square-section bamboo contrasted with natural bamboo cut from much younger stems.

99

Pressed veneer bowl 153 x 43 x 153 ⊗

A clever utilisation of wood offcuts. Cut into thin veneers, they are then woven into sheets and shaped under high pressure, and with minimal amounts of adhesive, into bowls, trays and so on. Straw is used in a similar way.

100

Hammered brass bowl 170 x 100 x 170 ◉

Beaten by hand out of annealed metal over a pitch-former, this bowl still retains the hammer marks, though similar bowls are often smoothed out. More complex shapes can be made by soldering together sections, as in the traditional narrow-mouthed water-pots. In the West this type of handwork can only be economical on a very small scale using precious or semiprecious metals to produce jewellery.

101

Ceramic slab bowl 193 x 55 x 193 ◎

This bowl was bought in Tunisia where this half-yellow and half-green glaze is very popular. This is handwork with the minimum of skill. The clay is rolled out, pressed into a plaster mould, trimmed around the edge, biscuit-fired, dipped into the two buckets of glaze and then fired again. It is, however, a rather beautiful object. Because of its simplicity, details like the slight bleed where the two glazes meet become focuses for contemplation.

102

Turned stone bowl 205 x 75 x 205 ✪

This bowl always conjures up for me the sound of stone-chipping and the whirr of bicycle-powered lathes dispersing into the crisp air of the desert. I know this is a sentimental view. However, the noise and pollution of the modern factory is something that tends to be ignored where time-and-motion economics is the all-important factor.

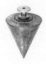

103

Plumb 45 x 90 x 45 ✪

Hung on the end of a length of string to indicate a perfectly vertical line. The plumb has to be perfectly balanced, so turning it on a lathe from a solid piece of metal is a lot more accurate than casting it.

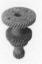

104

Cogs and gears 160 x 240 x 160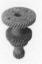

These are gears from a car. In the mechanical age, cogs were made in almost any scale and in numerous materials. Think of the wooden cogs and gears in a windmill, or the tiny cogs inside an analogue watch which in turn are mounted on tiny bearings made from jewels of ruby or corundum.

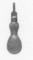

105

Screwdriver 27 x 97 x 27

This screwdriver has a very hand-inviting handle. Wood and stone is slightly compressed and burnished by wear, acquiring a polished look; think of old flights of wooden or stone stairs. This is an effect that does not happen with man-made materials, which generally start to look shoddy with wear.

106

Buttons 25 x 4 x 25

These are traditional shell and bone buttons. The Pearly Kings and Queens of the East End of London use buttons cut and drilled from the linings of abalone shells as decoration for their suits, which are covered all over with constellations of them.

107

Pig vertebrae e.g. 63 x 70 x 45

The vertebrae stretch from the base of the skull to the tip of the tail. Along their entire length runs a connecting hole through which runs the spinal cord; from this branch the nerves, which communicate with the whole body. Vertebrae in different sections of the spine have different functions; each has individually evolved to connect with other bones such as those of the pelvis, ribcage and skull. Each vertebra is separated from the next by a disc of spongy cartilage, and these discs are

what give the back its flexibility. There is not much give between one vertebra and the next, but if many segments move a small amount the overall curve becomes more significant.

The word 'backbone' is used as an analogy for the core of an organisation, and the adjective 'spineless' implies weakness of character.

108

Scaffold clamp 150 x 100 x 55
This clamp has a bonelike quality. I like the fluidity of its folded form.

109

Hip-bone 70 x 20 x 9
This is part of a small—mammal's pelvis. The end of the thigh-bone articulates with the dishlike socket.

110

Crab claw 25 x 97 x 17
Crabs like all crustaceans have a hard exoskeleton which they eventually grow out of. In fact, several times in their lives they shed this skeleton and grow a new one. Long ago, I was told that after the crab sheds its shell it also loses its ears. When the crab grows its new shell it has to insert a single grain of sand into its ears in order to hear again. I do not know if this is true but I like the story – it sounds like the basis for a fable.

111

Clothes-peg 15 x 110 x 15
This is the type of peg traditionally sold door-to-door by gypsies. It is a very simple design, which partially splits a peg of beech along the grain and exploits the wood's natural springiness to function as a clothes-peg.

112

Buffalo-horn comb 182 × 45 × 5

Buffaloes are used as transport in a lot of developing countries. Buffalo horn is a very eco-friendly material, a natural plastic. It doesn't require any unnecessary slaughter; buffaloes shed their horns periodically and grow new ones. This comb is sawn by hand from a flattened section of horn.

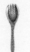

113

Carved knob 65 × 65 × 65

I carved this knob out of jelaton wood as a pattern to be cast. It is much harder conceptually to carve than to model. Carving involves removing what is not there to reveal what you envisage. It is also harder to reverse mistakes.

114

Coconut-palm salad fork 54 × 220 × 25

There are millions of coconut palms burnt every year around the world. Except as fuel, the wood is very underused due to its extreme hardness, though it can be made into beautiful furniture. The rest of the tree is used for all sorts of products: the hairy covering of the coconut husk for string and matting, and the actual husks ground up and pressed into medium-lifespan tableware.

115

Printing block 56 × 83 × 48

The symbol on this carved wooden printing block is loosely based on the *kalka*, an ancient symbol thought to have originated in Babylon and then spread to India and prehistoric Europe. It originally represented the growing shoot of the date palm, thus symbolising the tree of life.

116

Driftwood 90 x 125 x 40

Scraps of wood cleaned and polished by the action of the sea on the shore often exude a sort of self-contained presence. Display them against a plain background and they could be sculpture, and yet their formation is purely accidental.

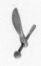

117

Shoe-keeper 55 x 250 x 230 ✖

Looking at this object I involuntarily flex my feet and curl my toes. It is placed inside the shoe and tightened up to keep the shoe from collapsing and folding up.

118

Bendy wood 590 x 410 x 70 ✖ ◎

Bendy wood is solid hardwood which has been steamed to soften its cell structure and then compressed longitudinally, making it very bendy. This piece started as a flat sheet of wood. I sawed longitudinal slits in it, then bent it into shape by hand. The wood stays in its bent shape unless it gets wet.

119

Worm-eaten driftwood 100 x 365 x 47 ✎

Woodworm is so common in furniture over a certain age that reproduction antiques often have simulated woodworm applied to them. A very large percentage of woodworm can be present in a beam before it is deemed structurally unsafe. This piece of driftwood has been washed pest-free and now looks very decorative. Although it is thoroughly worm-riddled, it is still remarkably strong.

120

Chalk 48 x 78 x 20

This piece of chalk with holes instantly makes you think of the sculptor Barbara Hepworth, who specialised in this sort of elemental form. The holes in this chalk are made by a drilling mollusc called a piddock. The shell of the piddock is sculpted with tough concentric rings, which help it to bore into the chalk for protection.

Stones on the beach have been formed first by millions of years of compression and then by the effects of weathering and erosion. It is only an act of choice, governed by my own sense of style, that has led to them being included on this page. I live a few metres from a pebbly beach, and I am fascinated by how different people – in particular, children, who are not so self-conscious about their choices – are attracted to different types of stones. Some like palm-sized smooth stones; some like interesting stones with strata or fossils in them; others only like stones that remind them of something else – teddy-bear stones, heart stones, hammer stones.

121

Iron ore or Haematite 60 x 50 x 70

Lumps of haematite show variations of the same bubbly pattern at different scales, demonstrating the principle of fractals. Fractal geometry often applies where a shape has self-similarity – that is, the details look much like the larger picture.

122

Marble-veined slate 50 x 50 x 20

These slices of sedimentary rock made from layers of black slate with thin streaks of white marble, then worn smooth by the sea, have a wonderful graphic quality. Alan Fletcher's book *The Art of Looking Sideways* features an entire alphabet made from similar pebbles and photographed by the Italian designer Italo Lupi.

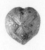

123

Sea-urchin fossil 38 x 42 x 25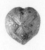

Fossils are a record of life on earth millions of years ago. They are natural casts left in sedimentary rocks when the original animal or plant decays, or when minerals combine with hard tissue such as bones or shells, calcifying it and turning it literally into rock.

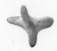

124

Stag-horn flint 55 x 40 x 40

Flints are almost pure silica, and derive from the bodies of marine creatures, especially sponges. They are found in layers in chalk. This strangely branched flint was formed when the burrows of ancient crabs and lobsters were invaded by sponge-derived silica which then turned to stone.

125

Flint from Henry Moore's garden 60 x 140 x 45

When I was an art student, one of my tutors was an ex-assistant of the sculptor Henry Moore, and he took us to meet Moore and look around his gardens and studios. In one studio there were maquettes for his sculptures. Some of them were little more than flints with a few clay additions. These had subsequently been worked up into full-size bronzes. Wandering around his gardens later, I noticed this flint in a newly dug rose-bed – I like to think of this as an embryonic Henry Moore that was missed by fate.

126

Flint axe 40 x 95 x 17

This flint axe was made over a million years ago. The edges are carefully chipped away to make a cutting surface. Similar tools were being made all over Africa, the Middle East and Europe. The finest of these tools show an appreciation of symmetry and aesthetics, and a pride in workmanship, which goes beyond the functional. Lyall Watson has suggested that they are 'the first real

evidence of style'.

One of my daydreams when I was a child was to find a flint axe, give it to a museum and have my name on the label. Despite years of looking, I never achieved my ambition. This one was given to me by a friend who found hundreds washed up on the beach when he was a child in Denmark. He also taught himself to make them.

127

Round flints 45 x 45 x 25

A lot of British beaches – for example, Brighton beach – are composed almost entirely of flints worn down into rounded pebbles by the constant action of the tide. Perfectly spherical stones, as opposed to merely rounded ones, are rare finds, although some beaches do yield more than others. I have a theory that beaches near river estuaries have more round stones, the pebbles there being subjected to a more complicated movement of currents and tides.

128

Sea-smoothed slate 40 x 18 x 70

An accidentally beautiful object which invites you to hold it in the palm of your hand. The straight line produced by the vein of marble contrasts with the curves of the stone. Roundness is often a symptom of age. Rounded edges can be used in design to make objects wear better.

129

Sea ball 70 x 70 x 70

These objects were a huge mystery to me when I found them washed up in drifts on the beach in Tunisia. They are fawn in colour and appear to be perfect felt spheres. At first I assumed they were something to do with camel dung, but they are in fact the resistant cellulose fibres of sea grass rolled into tight balls by undersea currents.

130

Goose egg 65 × 90 × 65

The egg is a self-contained living system, providing protection, warmth and nutrition. Its form makes it resistant to breakages and also more comfortable for the bird to lay. The egg is perfect packaging.

131

Sucked gob-stopper 30 × 30 × 25 ◌

Imagine a screwdriver handle or a pen made from a plastic constructed in coloured layers, like a gob-stopper, which gradually wears away with use so that you end up with a personalised handle.

132

Ceremonial brass water-pot 120 × 120 × 120 ▣

This seems to me to be an object that is perfect in its context and setting. The vessel is cupped in one hand and dipped in the river, and is then used to pour a stream of water over the head in an act of ritual cleansing. The shiny surface reflects the sun and water, marking it as special, while the simplicity of form marks it as timeless.

133

Pin gauge 75 × 130 × 17 ▣

This simple but clever little tool is to help you draw out the profile of a moulding or an indent. In this case it marks the profile of the brass bowl next to it.

134

Oak set square 118 × 277 × 10 ✪

A pleasure to use. Tools can be inspiring in themselves. Using this set square you would be loath to make anything bodged or ill-proportioned.

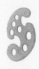

135

French curve 73 × 132 × 2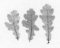

I've always found French curves incredibly difficult to use – a bit like a scale rule or a bicycle span-
ner, they're always confusing. Drawing complex curves on a computer is a doddle by comparison.
CAD has changed product design forever – cars will never be the same again.

136

Oak leaves e.g. 70 × 35 × 1

Most people have a mental picture of an oak leaf in their head and could transfer it to paper; the
tendency is to draw the leaf symmetrically and to fit the undulations within a squat oval shape. In
fact, that ideal oak leaf is fairly difficult to find in nature. In September, I picked a small branch off
an oak tree with approximately 200 leaves on it, and the leaf furthest to the right of the page was
the closest I could find to the archetypal oak leaf.

The American sculptor Allan McCollum writes of mass production, 'I feel that the rhythms of
industry are operating in constant imitation of or homage to the productivity of nature. Isn't this
what impresses us most about the natural world? The way it replicates itself indefinitely?'

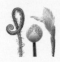

137

Spring buds

The fundamental difference between plants and animals is that animals need complex organic
matter to feed on and all plants need is air, water and sunlight. Leaves are thin and flat to present
as much surface area to sunlight as possible. Their shape is maintained by the turgidity of the
midrib and veins, which act like the struts of a kite or the stays of a sail.

These pictures were taken in the spring when everywhere, even the cracks in the pavements,
seems to be bursting with new greenery. All the buds are in a state of motion, unfurling, fanning
out and uncrumpling. This movement is ingeniously orchestrated by plant hydraulics – in other
words, by the turgidity of the leaves. At the end of a plant's life the process is reversed as the

moisture leaves the plant and aids the dispersal of the seeds. In the 2003 landing of the Mars Rover spacecraft, a lot of the manoeuvres imitated plants: the parachute landing, the bouncing capsule and the unfolding of the craft.

138

Lamb's Ear leaf 30 × 60 × 1

Both the common name for this plant and the Latin classification of its leaf shape are very evocative. The leaf is described as 'pubescent', which conjures up a picture of a fuzzy-chinned boy. These plants are adapted to a hot and windy Mediterranean coastal climate. The silvery-grey colour reflects away the sunlight, and the hairiness protects the plant from extreme evaporation.

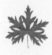

139

Pelagonium leaf 90 × 70 × 1

A modest plant with a very beautiful leaf shape.

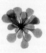

140

Saxifrage 30 × 30 × 25

The leaves on this small succulent plant spiral tightly around its stem in a configuration which is also found in flowers such as the chrysanthemum and seeds such as the pine cone.

141

Plaster plaque 150 × 150 × 50

Cornice work in houses passes in and out of fashion. This modern plaque is based on a pattern of acanthus leaves, a traditional adornment of pillars and plasterwork since the time of the Greeks.

142

Leaf plate 250 x 1 x 253

This plate, mass-produced by hand, is of a type still found in cafés in India. It is made from leaves stitched together with thorns. The plate is an example of recycling by directly using a natural or manufactured object or material that is no longer needed for its original purpose. In the developing world, ingenious reuse of redundant objects is common. I have seen a non-functioning fridge used as a cupboard, and metal cans are used for all sorts of purposes, including cladding for house walls. In England, allotments are still sometimes occupied by sheds made from old doors, and many a car has ended its life as a hen house.

143

Penis sheath 40 x 270 x 40

This is a ceremonial penis sheath from Papua New Guinea made from the skin of a gourd.

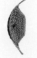

144

Palm-leaf bag 535 x 162 x 20

This traditional bag from Papua New Guinea is carried by both men and women as a receptacle for *paan* (betal leaf), betal nut and cigarettes.

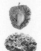

145

Dried fruit and veg. 60 x 35 x 23 and 45 x 55 x 24

This weird mummified object was produced accidentally when my children used a potato to furnish ammunition for their spud gun and then left it in some hot dusty place to dehydrate. The other object is a once-bitten apple left in the workshop by students, where the hot dehumidified sawdusty atmosphere reduced and wrinkled it. A friend keeps a dried potato in her handbag as a good-luck charm. Other similar phenomena include Amazonian shrunken heads, and traditional tool handles made from sea-kelp stems which shrink onto the hasp of the tool, forming a wrinkled hornlike handle.

146

Shell purse 105 x 50 x 30
A very sexy object. Originally used for carrying snuff.

147

Paper bag 90 x 160 x 55
Paper is a necessity in modern civilisation, and the development of machinery for its high-speed production has been largely responsible for the increase in literacy and the raising of educational levels throughout the world. This small paper bag originally held roasted peanuts and was bought from a street vendor in India. The base is made from a local-language newspaper; the main part is made from the page of an exercise book on which there is a list of exam questions in English for what seems to be a degree in clinical psychiatry.

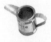

148

Pouring can 235 x 140 x 110
Minimal intervention gives this discarded tin can a new lease of life.

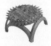

149

Tyre stool 580 x 580 x 310
This was the last object I chose to put in this book, and it's also the largest. I couldn't resist it; it's such a great use of discarded tyres! The legs are reinforced with wire for extra rigidity, as they use the sides of the tyres. The seat is springy and comfortable, and the zigzaggy edge gives the perfect decorative finishing touch.

150

Noodle doodles approx. 10 x 5 x 1
Inspired by tinned pasta shapes, I made this picture depicting some of the objects from this book

as pasta pictograms! It is surprising how, with such minimal information, the objects can be differentiated and identified. Have a go!

151

Bolt-hole 65 x 65 x 32

A bolt-hole. Or is it a hinge bracket? Or does it have one function vertically and another horizontally? A lot of objects become symbols or verbal metaphors for something that could not be guessed at by looking at them, but which is to do with cultural knowledge and tradition. 'Bolt-hole' has another meaning as a place that can be run to in times of stress or danger.

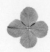

152

Four-leaf clover 15 x 15 x 0.5 ⊘

Four-leaf clovers are a traditional symbol of good luck. Searching for them is one of those endless and meaningless summer activities that are really just an excuse to be outside under a blue sky. Apparently, it is possible to breed a four-leaf clover by crossing alfalfa and clover; but this defeats the point, which, of course, is the endless search. The clover with the record number of leaves – 18, no less – was found in Japan in 2002.

153

Nutmeg grater 60 x 127 x 13 ▢

The sculptor Mona Hatoum, who defines herself stylistically as a modernist/surrealist, uses the grater and other kitchen implements as recurring motifs in her work. By greatly enlarging the scale of the grater and the moulee food grinder she aims to create a sense of physical unease in the viewer. Something that has a similar effect on me is the sight of an empty light socket.

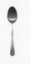

154

Silver spoon 25 x 120 x 10

The proverbial silver spoon symbolises birth into a wealthy family. Spoons are a beautiful shape, whether carved, beaten or cast. However, to those people who prefer to use their hands to eat, they must seem strange, cold and alien.

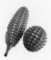

155

Wooden hand-massager 45 x 135 x 45

This carved hand-massager looks very much like it has been modelled on a vegetable or seed-pod: the 'stalk' is carefully painted red with a deep purple tip. It is made by turning a piece of wood in concentric rings and then sawing it in the opposite direction.

As a design teacher, I sometimes find it difficult to get across to students the difference between imitation and inspiration. I want this book to convey the idea of likeness rather than sameness. Claes Oldenburg, the American pop artist, could relate an advert of a woman's panty girdle to the entrance of the stock exchange, or morph a typewriter into a slice of pie just through drawing. Today imitation is everywhere; there are endless Disney characters as bubble-bath bottles or toilet-roll covers in the shape of milkmaids. Kitsch has a humorous role to play in design. The next few pictures deal with imitation that also works well on a structural and functional level.

156

Plastic duffel toggle 17 x 60 x 13

Horn tips were used historically for garment fixings because their streamlined shape made doing up easier; once again, plastic is more convenient and cheaper than the traditional material.

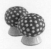

157

Mushroom cruet 45 x 50 x 45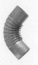

The simplicity, directness and gentle humour of the decoration on this cruet set is typical of modern Danish design.

158

Torch 35 x 105 x 35

This tin torch is made in the shape of a Doric column. The form does not seem inappropriate to the torch's function as a beacon of light, and the corrugations in the metal make the case stronger and easier to grip.

159

Bent ducting 80 x 195 x 195

How successfully a flat sheet material can be rendered in 3D depends to a large extent on the nature of the material. Sheet metal has the advantage of staying put once formed.

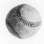

160

Baseball 80 x 80 x 80

Unroll this in your imagination: tessellations – two identical shapes fitting perfectly together around a sphere. Footballs are constructed from equal-sided hexagons and pentagons which also tessellate together, and oranges are made of identical segments.

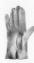

161

Leather glove 140 x 220 x 20

Tailoring can be an inspiration to the 3D designer or sculptor. Fitting a sleeve into a garment, or a thumb into a glove, is a perfect lesson in converting 2D into 3D.

162

Paper spiral 180 x 300 x 60

Just the sort of paper doodle that looks like it might lead somewhere. The architects Zaha Hadid and Frank Gehry both start their projects with paper sketches that look to the uninformed like crumpled pieces of paper, but which turn out years later to look remarkably similar to the finished building.

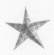

163

Christian star 700 x 23 x 700

This is a traditional Christmas star from Kerala, India, where there are a large percentage of Christians. The stars are hung outside people's houses, often illuminated by an electric bulb.

164

Cardboard spacing 135 x 225 x 25

This concertinaing cardboard spacing is used inside thin plywood doors and tabletops to form a hollow, lightweight structure with the appearance of solid wood.

165

Recycled kettle packaging 193 x 225 x 77

Pulped recycled paper is increasingly being used instead of vacuum-formed plastic for packaging of electrical goods. There is a whole family of recycled products made from ground-up rubbish compressed with some sort of binder. The English company Smile Plastics specialise in making sheet material from various recycled substances. The appearance of the sheet varies according to what is being recycled, which can be anything from vending-machine coffee cups to mobile phones.

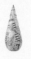

166

Papier-mâché nodder 65 x 155 x 65

I made this as an experimental model when I was thinking of designing a lamp with a self-righting base. It is hollow, and weighted down with lead fishing shot. I never made the light, but I kept the model because there was something magical about the way I could poise it right on the edge of a table, leaning over, and it wouldn't fall!

167

Paper doily 112 x 0.2 x 112

A paper doily is one of those kitsch anti-design objects that I ought to hate; but, when presented with this one on a saucer under my fruit salad, I rather liked it and sneaked it into my bag to take home. I like the casual design of it – the way the repeated flowers are supposed to be evenly spaced but don't quite work out that way. I also like the way it has been cut out but also slightly embossed – the whole thing has an unselfconscious, handmade feel to it even though I know it has been mass-produced.

168

Book 128 x 194 x 11

Books as we know them today have been around since early Christian times. They are a very clever design which could never have happened before the invention of paper, in much the same way as the bicycle could not have been invented before the wheel.

169

Origami boat 100 x 60 x 45

Origami is a traditional oriental craft; the challenge is to make three-dimensional structures from paper without any cutting or gluing. It is popular worldwide; different folds are represented by symbols and thus origami can be communicated across language barriers. In the last 20 years

links have been made between origami and mathematics, and more recently with computational geometry. Computer programs developed for origami have been used for other more practical applications – for example, the folding of car airbags, which need to pack into a very confined space while also being able to unfold in a way that does not cause injury.

170

Fractal card A4
This ingenious model, made by cutting and folding a sheet of paper, demonstrates the principle of fractals.

171

Chinese lantern 140 x 280 x140
Curves produced by a series of tiny tucks.

172

Cup-cake case 60 x 25 x 60
Deceptively simple.

173

Bun mould 86 x 30 x 86
An accuracy that cannot be maintained with paper.

174

Oil lamp 50 x 120 x 50
While in India we were hijacked by a rickshaw driver with an agenda. I think he was a bit disconcerted when we didn't bite at the spice stall or the essential-oil shop, but instead bought this lamp, which I noticed out of the corner of my eye as he was guiding us elsewhere. It amuses me to think that these oil lamps are now probably a regular part of his itinerary.

175

Coal shovel 70 x 155 x 72

The exaggerated folds form the shovel and also add a decorative element.

176

Foil takeaway tray 125 x 155 x 50

This belongs to the category of objects that are taken completely for granted, but which have passed the test of time and are actually very well designed.

177

Bunny jelly mould 110 x 210 x 110

The bunny mould was a ceremonial part of my childhood. It would come out at birthdays. These moulds are slightly flattened on the top so that you can stand them in the fridge without spilling the liquid jelly. In England, rabbit symbolism derived from the Easter bunny; in Germany, at Easter they use two-part cake moulds in the shape of baby lambs.

178

Dust mask 150 x 70 x 1

The aluminium of this dust mask bends to take the clip-on gauze filter and also to fit the individual shape of the user's face.

179

Draughtsman's clip 16 x 50 x 30

Clips have now been replaced by masking tape, a conceptual leap in design!

180

Rotor 330 x 330 x 80

There is a famous story originally told by the artist Léger about a visit in 1913 by Duchamp and Brancusi to the *salon d'aviation*. The pair were looking at an aeroplane propeller when Duchamp turned to Brancusi and exclaimed, 'Painting is finished'.

181

Manipulated pipe 27 x 220 x 20

I pinched this piece of pipe from a roboticised furniture factory. It is a component for joining the metal legs to the plastic seat, and is very ingeniously constructed by pinching and bending a length of pipe in various ways, thus making a strong but comparatively lightweight component.

182

Hair-clip 15 x 50 x 20

This hair-clip is a very clever little device cut from sprung sheet metal. I remember, when they first appeared in the shops in the 70s, design students would carry them around in their pockets, absent-mindedly clicking them back and forth and gazing at them in admiration.

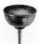

183

Oil can 53 x 75 x 53

Designed for a sewing machine and made by the process of metal spinning. The slightly domed base of the can when pressed dispenses a single drip of oil with a satisfying 'plip' sound. It is interesting how mechanical sound effects are being programmed into digital devices such as cameras and computers.

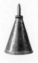

184

Oil can 60 x 105 x 60

This can is made by rolling a sheet of metal and soldering it into a cone. At the tip of the dropper is a blob of metal on a shaft, which drops down to let out a drip of oil when the can is inverted, and seals the spout when the can is upright.

185

Tea strainer 77 x 200 x 34

I bought this strainer in one of the stainless-steel-goods shops found in every town in India. I like the casualness of the handle shape and the way it joins to the strainer.

186

Laminated copper 75 x 165 x 35

This was part of an experimental lamp I designed. There is a symbiotic relationship between the two materials in the lamination. The plastic protects the copper and separates the two strips, and the copper's malleability gives form to the plastic.

187

Folding scissors 25 x 50 x 5

Made in China, the folding both saves space and prevents accidents.

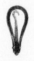

188

Buttonhook 28 x 62 x 5

A handy pocket-sized buttonhook which springs into its open and closed positions, and which was used to pull the loops over the buttons on button-up boots.

189

Coat-and-hat hook 75 x 115 x 97 ⬤

If you are going to cast millions of hooks, it seems sensible to pay someone with an eye for detail and proportion to make your initial pattern.

190

Umbrella stand 190 x 240 x 8 ⬤

This is the hanging part of a rather beautiful forged umbrella stand that I found in a skip.

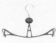

191

Coat-hanger 300 x 195 x 5 ⬤

A plastic coat-hanger displaying the triangulated structure of roof struts. With disposable plastic, the lighter the structure the better for the environment.

192

Picture-hook 31 x 50 x 30 ⬤

Interesting how the picture-rail in Victorian houses served as both an architectural feature and a very practical solution to the problem of hanging pictures. Without pictures it makes sense visually, but with pictures it makes even more sense. The points of the hook grab the rail and the weight of the picture pulls the points into the soft long grain of the wood, which means you can hang surprisingly heavy pictures by one or two flimsy hooks. Infinitely superior to struggling with Rawlplugs, cavity fixings, etc. – once you have the rail!

193

Spanish pressed-metal hooks 86 x 70 x 47 ⬤

Globalisation still leaves room for regional differences. In Spain the ends of coat-hooks are always wide and rounded to prevent coat damage (sometimes they are round discs); in England hooks always end with a point. I wonder if Spanish clothes have hanging loops.

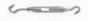

194

Tension hooks 130 × 23 × 6

A neat device for tensioning ropes or wires.

195

Ceiling-hook 80 × 80 × 70

I found this hook on the ceiling of a rented flat I lived in. The flat had been a sweatshop sewing leather jackets; the hooks were for ugly fluorescent lights on chains. The association with the lights meant it took weeks of mindlessly staring at the hooks from my bed before I noticed that they were rather neatly designed; I like the way they have been simply cast and then the hook flipped over.

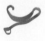

196

Sock-hook 70 × 30 × 2

This is just a very nice piece of anonymous design for the humble and short-lived purpose of displaying a single pair of socks for sale. I wonder what else this person designed and whether they were particularly proud of their sock-hook.

197

Scrubbing-brush 65 × 170 × 43

This curvy scrubbing brush just seems the perfect shape for the job.

We imagine we have choice, but if, for example, you look at plastic brushes in the high-street shops, from nail-brushes to brooms, you will see they almost all come from one manufacturer. It is hard to compete with this monopoly. In the pre-plastic days there were local craftsmen making brushes that would often have evolved a *wabi*-type beauty and would be closely adapted to their purpose.

198

Feather duster 250 x 530 x 250 ⊘ ◐

There is something slightly disturbing about a culture that buys peanuts to feed to garden birds and uses a brush made from feathers to destroy spiders' webs. In China it is possible to buy very cheap throwaway brushes made from whole birds' wings, which seems even more macabre.

199

Pan-scrubber 60 x 140 x 55 ⊘

This is a traditional pan-scrubber still found in Eastern Europe and Scandinavia; it is particularly efficient with scrambled eggs! It is made from broom root fibre, which softens when wet. The brush is double-ended, giving it twice the life expectancy.

200

Aerosol-top brush 49 x 49 x 49 ◐

A sort of 3D comb utilising the mouldability and bendy properties of plastic. This was incorporated into the lid of a can of suede spray – a use of plastic that I want to dislike, but find myself grudgingly admiring.

201

Sweeping-brush 90 x 380 x 90 ⊘ ⟳

The structure of plant stalks often consists of hard resistant fibres bound together by softer material. In Japan brushes are made from bamboo by treating the end of a bamboo stick so that the tough fibres are exposed, thus forming a brush with a handle. This Indian brush has been made in a similar way, but with lots of stalks bound together.

In India the brush is a very potent social symbol – almost an object of superstition.

202

Wire brush 55 x 265 x 20

A very expressive brush for polishing awkward and detailed metal components. I like the physicality of this brush, the way the metal clamps the bristles and then in turn slots into the handle, which is very obviously shaped for gripping.

203

Bottle-brush 23 x 210 x 23

The technology employed to make this brush, which started as a hand skill and then became mechanised, has also been imaginatively adapted to making very realistic Christmas trees.

204

Paintbrush 25 x 280 x 13

This traditional brush uses the natural springiness of wood to clamp the soft bristles.

205

Paintbrush 60 x 33 x 7

With its splayed bristles, a perfect brush for graduated strokes.

206

Teasel 75 x 150 x 75

A handsome weed used in the olden days to comb out wool. It distributes its seeds first locally through the shaking of its long stalk and then further afield as its tiny hooks attach it to the coat of a passing animal. Such seeds were the inspiration for the inventor of the Velcro fastener.

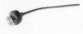

207

Poppy-head 30 x 70 x 30

An interesting, but slightly irrelevant fact – the seeds of the opium poppy are used to decorate bread, so it is possible to fail a drugs' test if you have eaten a seeded bun!

208

Gourd seed 209 x 50 x 60 ⊘

This seed very much reminds me of some of Richard Deacon's sculptures. It is interesting that he has equated the unitary, all-at-once impact of his sculptures with the construction of aeroplanes, seeds and fish, all of which he says are 'built all over' rather than 'from the ground up'.

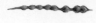

209

Twisted seed 115 x 10 x 7 ⊘

210

Clematis seed-head 50 x 40 x 40 ⊘

A bunch of seeds all with feathered tails to assist their flight away from the parent plant.

211

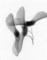

Sycamore seeds 115 x 35 x 5 ⊘

The ancestor of all propellers!

212

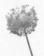

Onion seed-head 80 x 70 x 80 ⊘

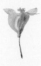

213

Begonia 25 × 40 × 40

The flower is shaped for flight; but when it dries out it loses its shape, so the seeds have to be dropped early.

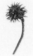

214

Spikey seed 20 × 50 × 20

This book is full of visual similes and metaphors, objects which in every way, except the visual, have little in common, but which share an essence of form or structure. The two pairs of objects on this double-page spread relate in this way, highlighting the characteristics that they share by association with each other. When you tune in to certain visual patterns you often see similarities in objects that other people looking at them with different criteria in mind would not perceive at all.

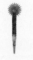

215

Perforation punch 70 × 12 × 5

A simple little tool for punching holes in leather to help with sewing. It works on the same principle as agricultural tools which make holes for seed-planting. Visually it is formally similar to the hole-punch. Being radially spiky on the end of a stick, it could also be part of a contrived verbal metaphor involving ploughs and seed-spreading.

216

Pine cone 100 × 60 × 60

The pine cone gripped its seeds in a spiral cluster as tight as newly wound string.

217

String 160 × 80 × 80

The string had the precise pattern of a pine cone.

218

Runner bean 22 x 12 x 8

Perfectly disguised as the light and shade on the soil, natural camouflage which prevents the bean being eaten before it has had a chance to germinate.

219

Bakelite plate 167 x 15 x 167

This pattern is produced by sprinkling Bakelite granules into the bottom half of a press-mould. The granules are then fused together at high pressure, which retains both their colour and distribution.

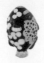

220

Squirting fish 27 x 35 x 65

The airbrushed decoration on this squirting toy is an impressionistic approximation of the natural colouring of the fish. It is a pattern that does not require accuracy and so does not reveal its flaws.

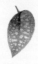

221

Pulmonaria leaf 100 x 55 x 0.5

I do not know if the spots on these leaves have any function. A lot of decorative garden plants are cultivars or hybrids. One particular plant has particularly bright and luscious flowers, so the plant breeder uses the seeds or a graft from that plant to grow his next batch of plants. He then again selects the plants with the showiest flowers and breeds from those again until a few generations down the line he considers that he has a new hybrid. This process has been used for centuries by farmers and gardeners, and is only a small step away from natural selection and survival of the fittest. Genetic engineering is a lot more worrying because changes can be made across species, as in the bizarre case of goats that are given a spider's gene that allows them to produce spiderweb protein in their milk.

222

Oyster shell 78 x 83 x 13

Sabi is a Japanese aesthetic that appreciates the patina of age and the enhancement of beauty brought about by the ravages of time – as in a castle ruin, or an armless statue. *Sabi* achieves its ultimate when age, wear and tear bring something to the brink of its own demise. The oyster shells that you find washed up on the beach, often in huge drifts, can tell you the story of their inhabitants' lives. The shells vary in shape depending on whether they grow in quiet or swift tidal waters, and grow thicker the longer the oyster lives. Cracks and holes, which result from accidents or attack, are sealed over, and the grit and sand that penetrates the inside of the shell is covered with lustrous mother-of-pearl. After the oyster dies the two valves are usually separated and continue to be eroded by the sea.

223

Hosta leaf 80 x 110 x 30

This leaf makes me feel more optimistic about the aesthetics of ageing: it is twisted, dry, frail and wrinkled, and yet triumphantly beautiful!

224

Mousetrap 180 x 65 x 40

And finally, a very delicately sprung Spanish mousetrap that is at once gruesome, intriguing, ingenious and economical.